THE ART OF
ENGAGEMENT PHOTOGRAPHY

All rights reserved.
Published in the United States by Amphoto Books, an imprint of the
Crown Publishing Group, a division of Random House, Inc., New York
www.crownpublishing.com
www.amphotobooks.com

AMPHOTO BOOKS and the Amphoto Books logo are trademarks of
Random House, Inc.

Library of Congress CIP data is available from the Library of Congress.

ISBN: 978-0-8174-0009-5

Printed in China

Cover and interior design by Megan McLaughlin
Front cover photograph by Elizabeth Etienne

10 9 8 7 6 5 4 3 2 1

First Edition

For opposite page: Nikon F100, 105mm Nikkor lens, Kodak
400CN film, 200ASA, 1/125 sec. at f/2.8

For page 4-5: Nikon F100, 85mm PC Nikkor lens, Kodak 400NC
film, 200 ASA, 1/125 sec. at f/2.8, natural ambient light

For page 6-7: Nikon F100, 85mm PC Nikkor lens, Kodak 160NC
film, 100ASA, 1/500 sec. at f/2.8, natural ambient light

For page 8-9: Nikon F100, 105mm Nikkor lens, Kodak BW-
400CN film, 100 ASA, 1/125 sec. at f/2.8, natural ambient light

For page 22-23: Nikon F100, 85mm PC Nikkor lens, Kodak B/
W400CN film, 100 ASA, 1/60 sec. at f/2.8, artificial, incandes-
cent studio lighting

For page 38-39: Nikon F100, Kodak BW400CN film, 200 ASA,
85mm PC Nikkor lens, 1/500 sec. at f/5.6, natural ambient light

For page 50-51: Nikon D3, 200mm Nikkor lens, ISO 200, 1/1250
sec. at f/4.5, Tiffen polarizing filter, natural ambient light

For page 72-73: Nikon F100, 105mm Nikkor lens, Kodak 400NC
film, 200 ASA, 1/125 sec. at f/2.8, natural ambient light

For page 82-83: Nikon F100, 105mm Nikkor lens, Kodak
BW400CN film, 100 ASA, 1/30 sec. at f/2.8, tripod, Nikon soft #1
filter, natural ambient light

For page 104-105: Nikon F100, 85PC Nikkor lens, Kodak 400CN
film, 200 ASA, 1/250 sec. at f/2.8, natural ambient light

For page 114-115: Nikon F100, 105mm Nikkor lens, Kodak 400CN
film, 200 ASA, 1/125 sec. at f/2.8, Tiffen #85B warming filter,
natural ambient light with white fill reflector

For page 138-139: Nikon F100, 105mm Nikkor lens, Kodak 160NC
film, 100 ASA, 1/125 sec. at f/2.8, natural ambient light

THE ART OF
ENGAGEMENT
PHOTOGRAPHY

Creative Techniques to Capture Couples in Love

AMPHOTO BOOKS
an imprint of Watson-Guptill Publications
New York

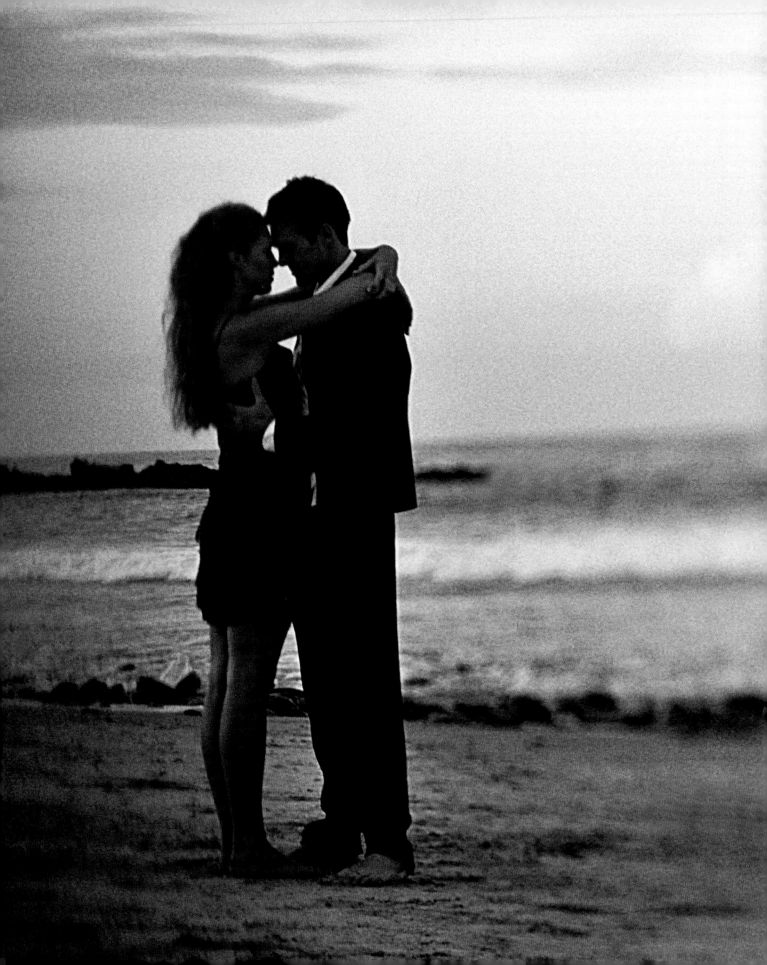

CONTENTS

I want to express my deepest gratitude to all the passionate, eager, aspiring photographers who have come into my life through my unique internship and assisting program. Their enthusiasm and hunger to learn gave me a wonderful platform of inspiration. While going through the day-to-day activities in and out the office, which involves market research, finances, self-promotion, location scouting, photo shoots, and client relations, I came to realize how much knowledge I had actually acquired over all these years. As a result of their endless probing questions, I finally decided to compile all my knowledge and write this book. I love teaching as much as I love photography and my goal for this book is to explain things in my no-nonsense, Midwestern way. I receive great joy in seeing my students apply these principles with their go-get-'em attitude!

Special thanks goes to my packaging box designer, Christine Mills, and to Jill Martin and Laurie Scavo, who all so carefully reviewed my manuscript as I wrote. Their passion, diligence, and perseverance made this book come together.

As we teach we learn and so it goes I want to thank all of you who taught me how to lead.

I dedicate this book to my family, for understanding an artist's path is different from everyone else's and for giving me the support I needed.

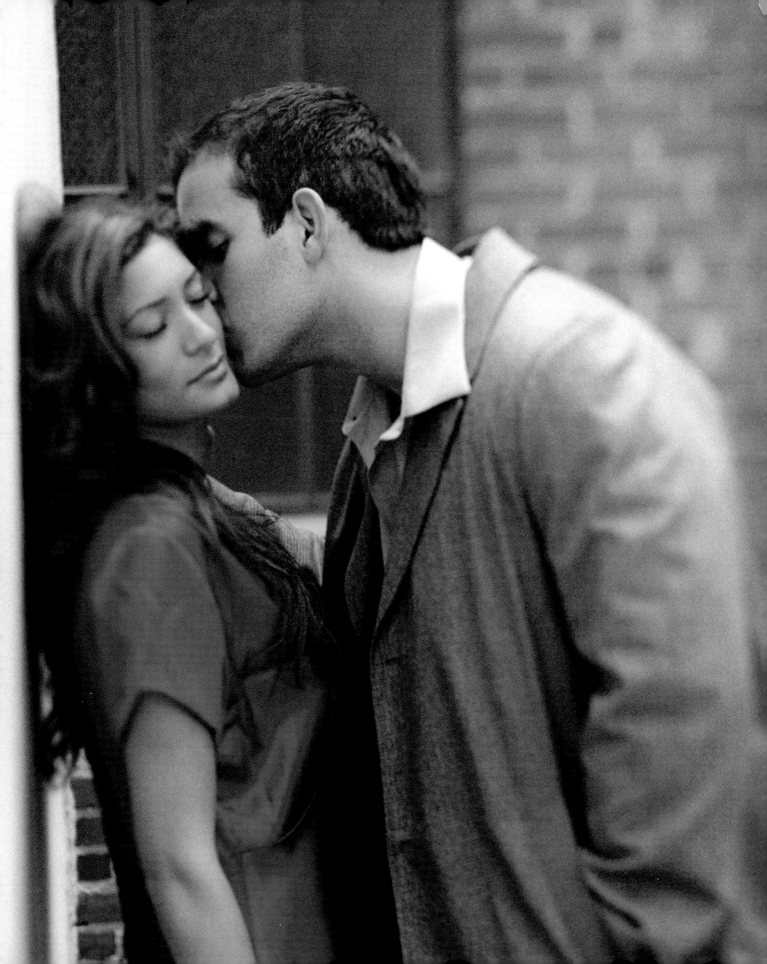

INTRODUCTION

If you still think of engagement photos as the standard posed portraits of couples that appear in the announcements column of your local newspaper, think again. Engagement images can be fun and whimsical, intensely passionate and sexy, sentimental and romantic. For that matter, engagement images don't even necessarily have to be for a couple's engagement at all: Some couples, whether they are about to be married or have been married for years, might just want an excuse to have romantic pictures of themselves. Whatever motivates a couple to commission you to shoot engagement images, the session opens up a new market for your photographic talents and comes with all sorts of other benefits, too—from challenging your creative skills in new ways to getting to know your clients before the wedding shoot.

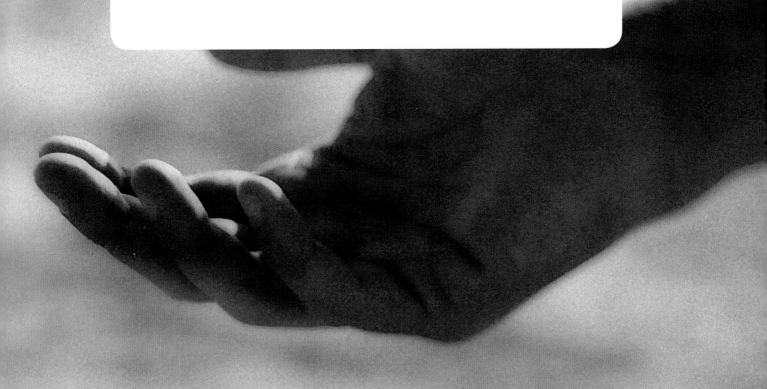

WHY ENGAGEMENT PHOTOGRAPHY?

For the couple, the engagement session is a special opportunity to pose in a stress-free environment of their choice, without the time constraints and pressures of the wedding day. This is the time of their lives when they feel young at heart, are caught up in the throes of romantic love, and look and feel their best. An engagement sessions allows them to capture the moment. For you, shooting an engagement session is a chance to explore a variety of concepts, themes, and styles.

Millions of photographers are now shooting engagement sessions. If you don't, you're definite-ly lagging behind your competition. In today's tight economy, more and more couples are opting for simpler, more intimate gatherings rather than big-budget weddings, leaving some extra money for a unique engagement shoot. Learning how to stylize and customize an engagement session requires a bit of work and thought on your part, but these images could take your photography business to the next level.

As a wedding photographer, I see four compelling reasons to shoot an engagement session.

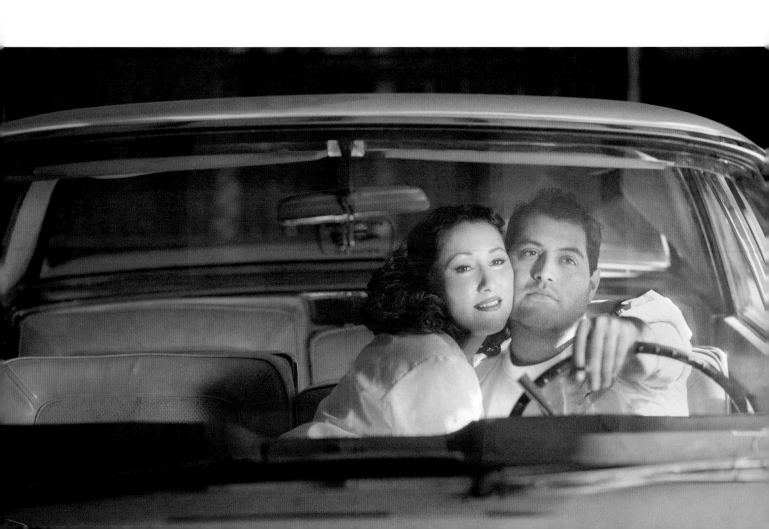

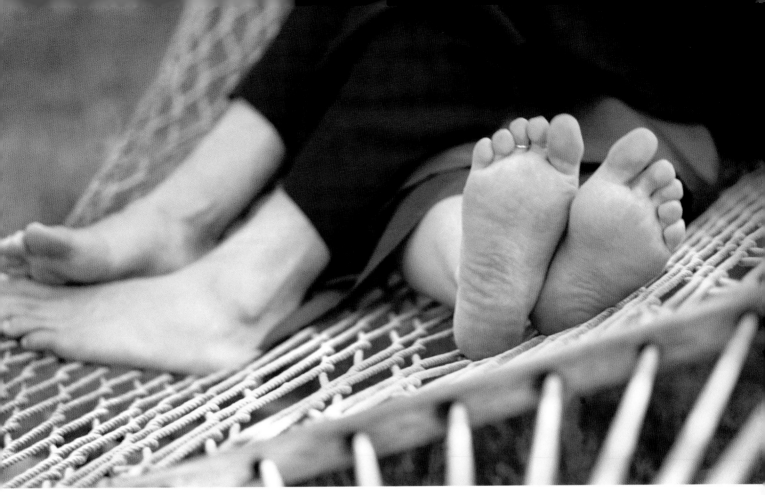

#1: Increase Your Income

The main reason to include an engagement session in your list of services is the opportunity to increase your income. With a few basic Photoshop skills, you can provide services every bride and groom want and need by creating a variety of items to be included in the wedding: handmade invitations, save-the-date cards, thank-you notes, digital projection shows, framed prints for the parents and bridal party, montage boards for the guests to sign at the registry table, and dozens of other items (see chapter 2). You might also later recycle the images into fine-art prints or stock images (see chapter 10).

The image is from my standard session, what I call my "Nobel Engagement Session" package—this includes one location and basic retouching. Giving your clients a choice of a few different packages ensure that there is a choice for everyone's needs and budget.

Nikon F100, 28–105mm Nikkor lens, Kodak BW 400CN film, 100 ASA, f/5.6 at 1/125 sec., natural ambient light

Opposite: Here are examples of different ways to sell a product. The image is from what I call my "Deluxe Engagement Session" package, which includes a retro-style theme option along with professional hair and makeup and a vintage wardrobe. It was inspired by the 1940s film *Nightmare Alley*, starring Tyrone Power and Joan Blondell.

Nikon F100, 105mm Nikkor lens, Kodak 400NC film, 200 ASA, 1/125 sec. at f/2.8, natural ambient light with gold fill reflector

#2: Practice Your Shooting Skills

Shooting an engagement session prepares you for the pressurized wedding day shoot, when you will be required to handle multiple issues simultaneously, successfully, and effortlessly. Think of the engagement session as the prerequisite to shooting a full-blown wedding—sort of the Junior Olympics version of the Olympics!

You will get the chance to learn your gear better, hone your directing and posing skills, and create images in a relaxed and fun environment. You'll also pick up some of the confidence, coordination, timing, and production skills you'll need for the wedding. After all, wedding day shots are some of the most important images the couple will ever possess, so why not get all the practice you can?

#3: Establish a Relationship Between Yourself and the Client

Shooting an engagement session establishes your relationship with the couple, enables you and your clients to become familiar with one another, and, barring a disaster, ensures that the wedding day shoot runs smoothly. A successful engagement session will also help establish your credibility. Chances are, the couple will be pleased with their choice of photographer as they show off the images to their friends and family, and, by the time the wedding day arrives, you will have gained their respect and trust. And with that comes the freedom to create dynamic images!

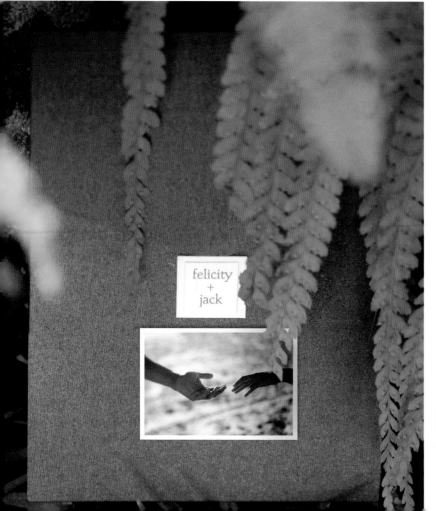

These wedding invitations use images from engagement sessions. I designed the cover image (left) and invitation insert (opposite) in Photoshop and printed them on my home printer. These are just some of the numerous items you can create and sell to your clients.

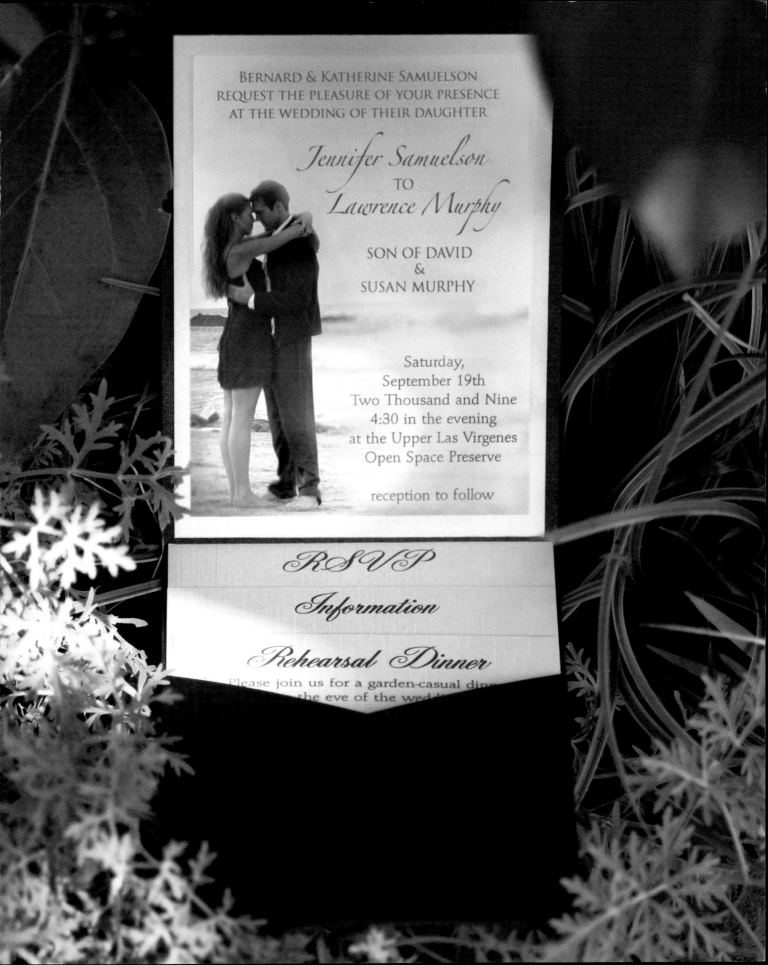

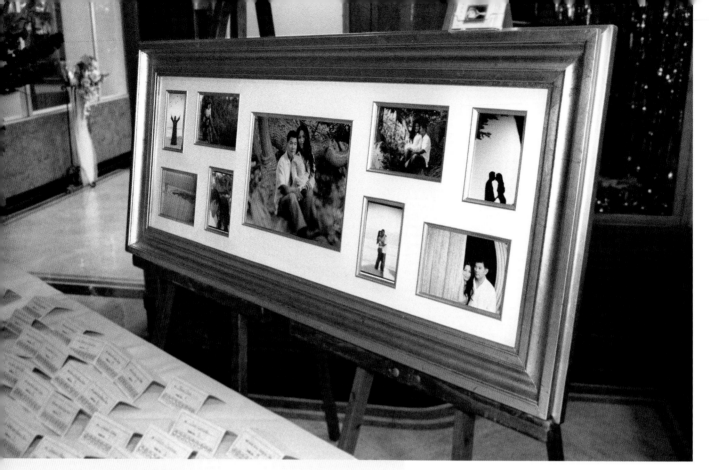

Images from a couple's montage frame show that creative abstract images traditionally make a strong statement, while a classic portrait can have a strong effect, too, if it is distinctive.

Nikon F100, 85mm PC Nikkor lens, Kodak BW 400CN film, 100 ASA, 1/500 sec. at f/2.8, natural ambient light

Left: A detail from a couple's montage frame (above) shows how a classic portrait can have the appearance of a fine art piece.

Nikon F100, 85mm PC Nikkor lens, Kodak BW 400CN film, 100 ASA, 1/500 sec. at f/2.8, natural ambient light

Opposite: I used these images in a special advertising portfolio to show to ad agencies and landed a huge ad campaign for a deluxe hotel chain.

Nikon F100, 85mm PC Nikkor lens, Kodak 400NC film, 200 ASA, 1/125 sec. at f/2.8, natural ambient light

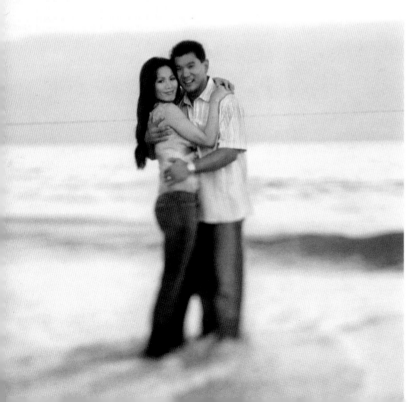

#4: Take Your Portfolio to the Next Level

Shooting an engagement session could be the bridge between earning a few hundred dollars and earning several thousand dollars! After you've captured a half dozen sessions or so, you should have enough images to make a presentation portfolio book dedicated to engagement photography. Your one-of-a-kind, highly stylized engagement images might not only impress your clients, but they may also catch the eyes of magazine editors, ad agencies, fine-art gallery owners, stock photo agencies, and décor art companies. Who knows where you next assignment might come from?

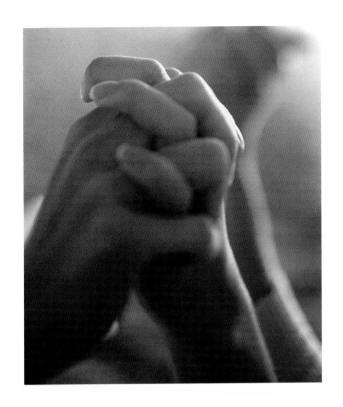

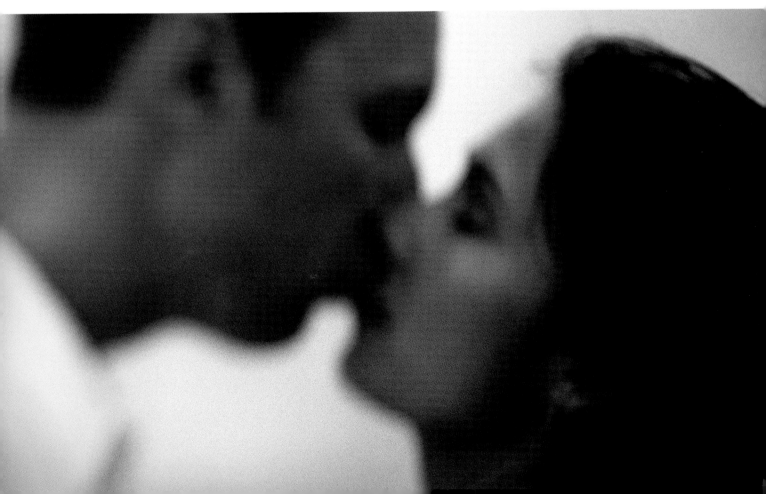

Elizabeth- My god dear what an artis...
no-nonsense attitude.

Chapter 1

LLING THE ENGAGEMENT
SSION TO YOUR CLIENT

Selling an engagement shoot is one of those win-win propo-
sitions for everyone. Couples get to have fun, escape the
pressures of wedding planning, feel like models or actors
as they do some role-playing for a day, and come away with
some really memorable images. A photographer who's also
going to be shooting the wedding gets to know a couple
better and has a chance do some prep work for the big day.
For a couple, the engagement shoot is one more element of
a memorable wedding; that's true for a photographer, too, as
well a source of some extra revenue.

GETTING BUSINESS

While you will usually sell an engagement photo session as part of a wedding package, you can also sell an engagement session on its own. Perhaps a couple can't afford your wedding photography but wants to work with you to produce some beautiful engagement images. Some clients come to me after they have already reserved another wedding photographer or even after they have had their wedding. I have also encountered a few elopers who opted out of a big wedding but wanted an engagement session to capture the moment.

Engagement photography is a great addition to your list of services. By promoting yourself as an engagement photographer, you make yourself that much more valuable. I let every wedding planner know that I shoot engagement sessions as well.

MAKING THE PITCH

Let your images do the talking. After all, they are your best sales tool. Most couples will contact you to shoot a wedding, without ever considering engagement images. Some may feel an engagement session is unnecessary, an added frill—until, that is, they see your images.

If your clients contact your first by telephone or e-mail, direct them to the engagement section of your website. When you do meet, hand them your engagement presentation portfolio book and focus the conversation on the images (see chapter 8). They can almost always envision themselves in one of these beautiful hardbound coffee table books. This usually does the trick and closes the deal.

If you meet in your office, place the couple on a

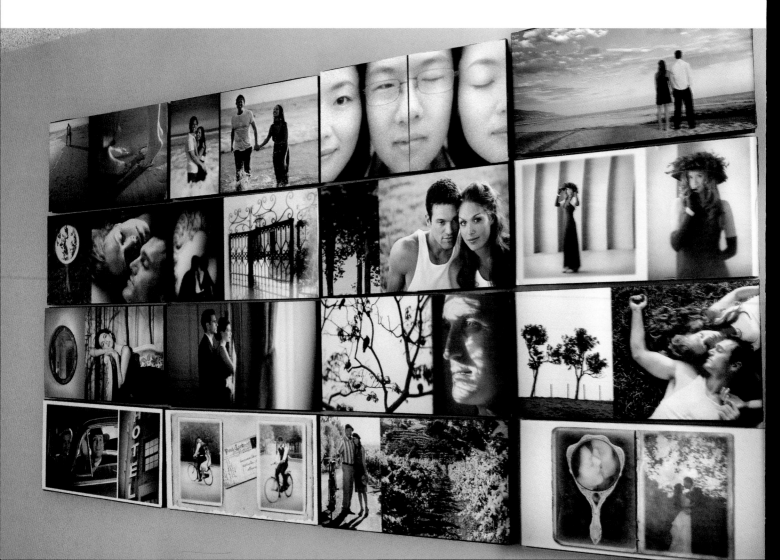

comfy couch facing a wall of your images, so they can view a large body of your work in one glance. For my office, I created a giant proof sheet that provides an impressive fine-art presentation and allows me to alternate images from time to time to always keep the display fresh. I wanted to display my work in a new and contemporary way, as opposed to using standard glass frames that would reflect glare from adjacent windows (I also didn't want the chore of having to clean the glass continually).

Once a couple has become engaged in your work, let them talk. Ask them how and where they met and what their common interests are. Sit quietly while they tell you about themselves. As they talk, take note of particular locations, shared enthusiasms or hobbies—a common love of dogs or horses, for instance—or whatever else they have in common. These tidbits will help you customize a theme for an engagement shoot (see page 44 for more specifics about choosing a theme).

Be enthusiastic but not pushy. You might gently remind the couple that an engagement shoot provides a once-in-a-lifetime experience to create unique images they can one day show to their children. Remind them that the engagement images are not just for the announcement column in the local newspaper but can be used for decorations, thank-you notes, custom stationery, and dozens of other products (see chapter 8). Let them know, too, that the engagement shoot is a chance to have some fun and escape the stress of wedding planning for a day. They might love the thought of retreating to a deserted sandy beach or hiking in a wooded canyon for a few hours to get away from all the craziness of planning a wedding. An engagement shoot can be the perfect romantic getaway and a chance to rekindle their love before the wedding.

A wall in my studio is designed to look like a giant proof sheet. I produce the images with an Epson archival printer, so they won't fade in sunlight or incandescent lighting. I then mount the prints on foam core via heat press and glue them onto shadow-box frames with the glass removed. Each image is independent and can be removed and exchanged.

PRICING YOUR ENGAGEMENT SESSIONS

Make the effort to seriously consider what your worth as an engagement photographer might be. A rough starting point might be to charge approximately 25 to 50 percent of the wedding price packages. In other words, if you charge $3,000 to shoot an average wedding, you might charge $750 to $1,500 for the engagement shoot.

Again, these are rough numbers. Three variables come into play with pricing: your time, your expenses, and the quality of your work. Look at each factor thoroughly.

➣ **Time:** In addition to the actual shoot, you will also need to consider your time doing research, scouting locations, prepping your gear, meeting with the client, sending e-mails, and making phone calls. Don't forget to include your postproduction time (wrapping the shoot, processing, editing, and retouching the images). You will eventually be able to save time when location scouting or researching, because you will have already done this before with previous shoots.

➣ **Expenses:** You will need to look at the cost of your supplies. These might include assistant fees, gas, parking, valet, meals, props, location permits or equipment rental fees, prints, album books, CDs, cases, postage, packaging, and anything else involved in preparing, producing, and delivering the final end product. Each job will vary, so it's imperative to keep an expense log.

➣ **Quality:** When taking stock of the quality of work, remember that what you charge for quality is relative. You might be the best photographer around, but no one is going to pay for top quality if they can't afford it. Consider the going rate of your existing competitors and the economic climate of the region where you operate. This being said, once your work has reached a level that is beyond that of your competitors, you should not hesitate to raise your rates based on the quality of your work and what the people in your target area can afford.

As you become more and more skilled, and have developed your unique style, reputation, and business production system, you may find your overhead expenses will increase because your production value costs increase. In other words, you are spending more to present a better product. This will force you to raise your hourly rates as you grow in order to survive.

My portfolio books sit on display easels in my office. I let my images speak on my behalf. I remind my clients of my many a la carte services, which include printing and designing exclusive engagement books.

I offer two different engagement session packages: a Deluxe package and a standard package (I call it a "Nobel" session). The Deluxe package includes professional hair and makeup, wardrobe and props, custom retouching, the option for a vintage-styled theme, and a choice of either two different locations or a studio setup. The Nobel session includes one location and basic retouching, and the clients handle their own makeup, hair, and wardrobe. Giving your clients a choice of at least a couple of different packages ensures that there is an option for everyone's needs and budget. Clients who choose a less-expensive option will have the chance to upgrade later, should they decide to do so.

Many clients may not have the time or need to meet with you in person. In this case, a good website is essential, as a place where clients can see images, read testimonials, view press quotes, and reserve your services.

Chapter 2

DEFINING YOUR TRADEMARK STYLE

Can people look at your images and just know they're yours? Defining a unique style is imperative to a successful photography business in today's competitive marketplace. Great photographers are paid top dollar for their trademark style. This is a style that only they can create and repeat time after time. Sure, the surprising image will still crop up, but clients are counting on your ability to reproduce the same look and feel of the images that first impressed them.

WHAT IS YOUR CORE VISION?

How do you find your trademark style? Think of the challenge as a quest to discover your inner truth. Ask yourself, "If I won the lottery and could shoot whatever I wanted, what would it be, and how would I shoot it?"

You can make an average portrait of a person sitting in a studio against a fake backdrop, similar to those you'd have done in a department store gallery, but is this unique? (Of course, it isn't.) Now, put that same subject in an unusual and beautiful setting, either on location or in a studio, add some unique lighting, a camera angle, expression, or composition with your own twist, and you might have something special.

Maybe you like to shoot with a certain lens, with

film rather than in digital format, with low lighting instead of bright lighting. A hundred photographers could be commissioned to shoot the same thing and they would capture it a hundred different ways, with a hundred different emotions and feelings. Each would be a trademark style. That's why we can easily recognize an Annie Leibovitz image, and the same might be said of those taken by Herb Ritts, Bruce Weber, Anne Geddes, or Mary Ellen Mark.

The only real way to develop a trademark style is to just shoot, shoot, shoot. You will begin to see a pattern in your shooting that evolves effortlessly, organically, spontaneously, subconsciously. When this pattern emerges, you will be operating from your heart and

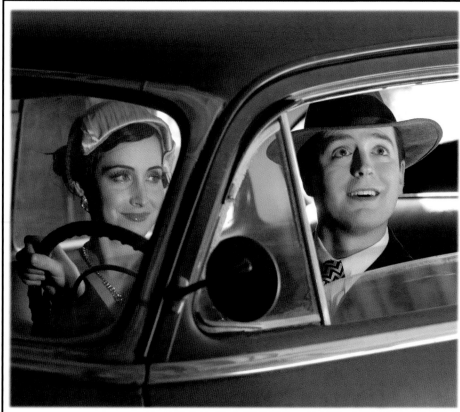

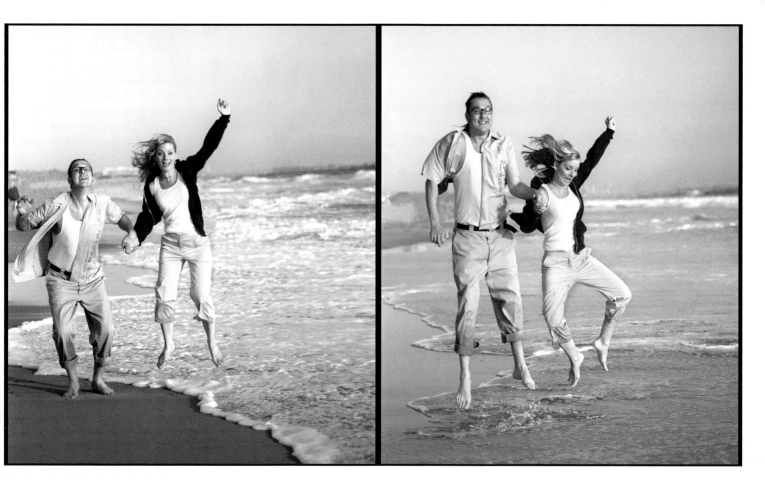

not your head. Once you recognize this pattern, ask yourself, "How can I apply this feeling to my engagement images and really enjoy shooting?"

As you increase your collection of images, you will begin to see a sort of story unfold, regardless of when and where the images were taken, who the subjects are, and what the themes are. From this vantage point, you will be able to begin thinking about how you want to present these images in your portfolios, on your website, or in other presentation and marketing materials.

Your presentation can be part of your trademark style as well. But while a design element may set you apart from other photographers, presentation alone cannot make up for a lack of consistency in your images. Placing a green border around all your images is not a shortcut to defining your trademark style. Many young photographers become hooked on design gimmicks and Photoshop filters to compensate for taking the time to develop strong images, and as a result their images look inauthentic. Great images come first; design is merely an enhancing element.

Opposite: Presentation is part of my trademark style. I am known for pairing images and presenting retro-style images with a soft edge to enhance the feeling of an aged and faded image. Combining two images into one not only makes use of valuable real estate, but it also gives the images a cinematic, storytelling feel. *Gas, Food & Lodging* was inspired by old travel postcards from the 1940s and 50s. See pages 96–97 for other images from this session.

(on left) Nikon D3, 105mm Nikkor lens, ISO 400, 1/250 sec. at f/5.6; (on right) Nikon D3, 85mm PC Nikkor lens, ISO 400, 1/250 sec. at f/2.8, natural ambient light

Above: A playful side can emerge as part of a trademark style. Using simple, unobstructed backgrounds allows the focus to be on the subject. Pairing two images together gives a sequential, cinematic feeling and enhances the sense of motion.

Nikon F100, 105mm Nikkor lens, Kodak BW400CN film, 100 ASA, 1/500 sec. at f/5.6, Nikon #25 red filter, natural ambient light

HOW I FOUND MY STYLE

The moment I decided I would give up trying to be a photographer was the moment I became one. It was the moment, as gurus say, "when the student meets his master" and "a writer finds her muse." I was living in Paris and had spent $100,000 on my photography education, learning every technical thing I could about photography. I was told by one art director after another, "Your work is good, but it's all mixed up . . . you need to define your style."

My style? What did that mean? I thought all I needed to do was define what I specialize in—fashion, magazine editorial, music, fine art, film stills, whatever. This was my style, so I would design portfolio after portfolio with what I thought was a collection of magazine-looking images or rock band/music images. Apparently, my portfolio was all over the map—one page had some 1980s crossed-processed images of a rock band, another was an Annie Leibovitz–style portrait next to some random product shot on black glass. I thought this was the way to show I had "versatility" and that I could shoot anything! After all, I didn't want to sell myself short, right? The problem was that I had become a jack-of-all-trades and master of none.

I was lucky enough to land a *few* jobs shooting record covers and press kits for the music industry, but they were scattered in between a lot of closed doors. God only knows how I survived. Feeling frustrated and defeated, I decided it was time to hang it up. I thought I just wasn't good enough or talented enough to compete with all the successful photographers out there. I came to the realization that I could not make photography my career. After all, I had started to hate the very thing that I once loved. This was a beautiful moment, for this was when I just let go. I put my camera down and walked away from it all.

I spent the next year waiting tables, cleaning toilets, and translating really bad film scripts from French to English. I would pick up my camera now and then "just for fun." Friends and I would drive to the Normandy coast for romantic weekend getaways and I always brought my camera along. I found myself shooting with more ease than ever before. I wasn't concerned about why I was shooting an image or which portfolio it would end up in. I was shooting from my heart instead of my head, shooting the things that inspired me—mostly romantic, sentimental, soulful, intimate images: a close-up of my boyfriend's hands folded at the café during a conversation, two lovers kissing along a creek bed, or an antique postcard.

After several years, I headed back to Venice Beach, California. I found a local community darkroom and decided to develop the numerous rolls of film I had shot in Paris. Because the drying rack for prints was often occupied, other photographers would remove prints when they were dry and set them in a general bin. During one of those busy afternoons, a man I'd never met handed me a stack of my prints. I asked him how he knew they were mine, and he said, "I knew these must be yours because they look similar to the others I saw you working on the other day. They all had the same style." Bingo! My "style" was born. From this point forward, people knew what images were mine even if my name wasn't stamped on them.

I began allowing myself the freedom to shoot whatever I felt. Whether it was for an ad campaign, wedding, or engagement session, I shot from my heart and left my head out of it. In fact, the very first request to shoot a wedding was from an art director at an ad agency. I told him that I was not a "wedding" photographer. He said, "We don't want a standard wedding photographer. My fiancée and I want *your* style." Wow! I was going to get paid for what I loved to do the most. I was no longer struggling to define my style. It was effortless; it just arrived. I was operating from a place of total freedom and creativity, and it was awesome.

Opposite: Intimate close-ups like this one are an example of my trademark imagery style.

Nikon F100, 105mm Nikkor lens, Kodak BW400CN film, 100 ASA, 1/60 sec. at ƒ/2.8, natural ambient light

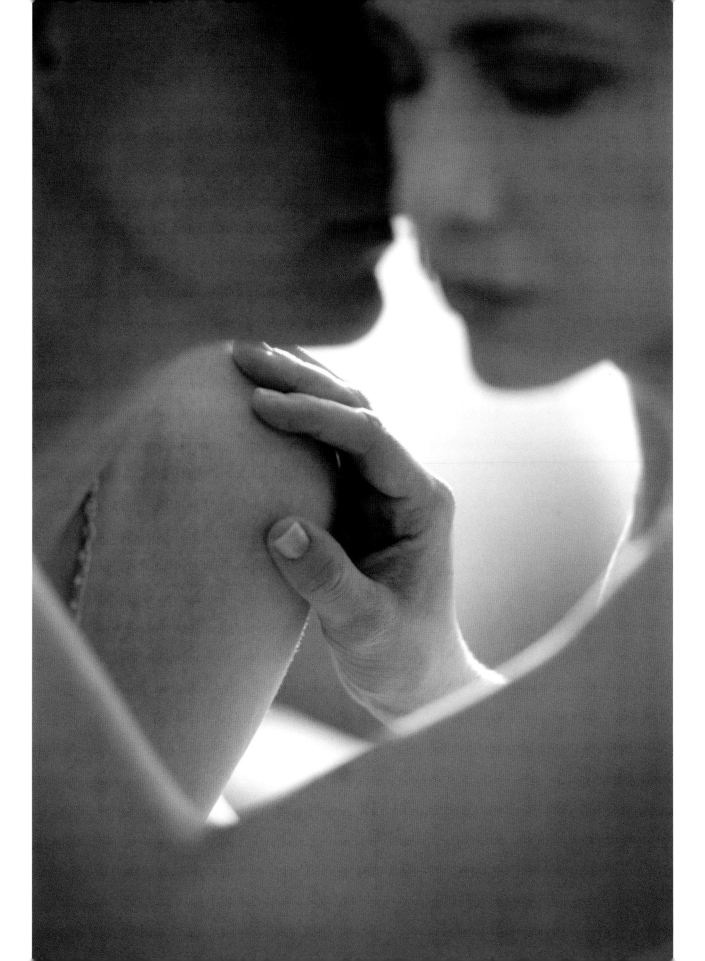

AN ENGAGEMENT SESSION . . .

in a Vintage Style

Vintage themes produce wonderful, evocative images and are a great deal of fun to produce, even though they require a bit more work—from preproduction time for scouting the right location, to finding the perfect period clothing and props, to directing the couple to maintain the period mood. You probably won't have to look far to find the perfect locale: An old building, a dusty alleyway, or just about any place that isn't what we would consider contemporary might fit the bill. Even a new building with reproduction architectural elements might appear vintage. Just look around you, or visit a local visitors center or chamber of commerce to inquire about historical places and buildings. You might be surprised at what you discover. Coming up with titles for vintage-shoot themes is also part of the fun, and you and your clients can continue to think up the best ones before, during, and after the shoot.

PREPARATION AND OBSTACLES: Shooting couples dressed in vintage-themed clothing on location in a public place can draw more attention to your production than usual. This means onlookers might gather, so it's often best to shoot quickly and discreetly and to avoid crowded spaces. You may also draw the attention of police asking for permits, so be prepared to explain that you are not doing a commercial shoot. A historic location or vintage prop, such as an old car, may require some cleaning and other prep work. So bring a clean cloth or small blanket the couple can sit on in case you can't get the objects 100 percent clean.

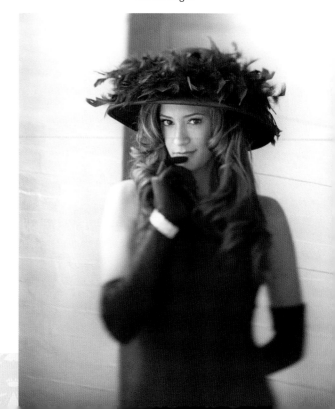

Glamorous attire and a stunning location were all I needed to recreate a vintage French fashion shoot. The white walls acted as a giant fill card bouncing beautiful light around from all directions.

Both Images: Nikon F100, 85mm PC Nikkor lens, Kodak BW400CN film, 100 ASA, 1/125 sec. at *f*/2.8, natural ambient light

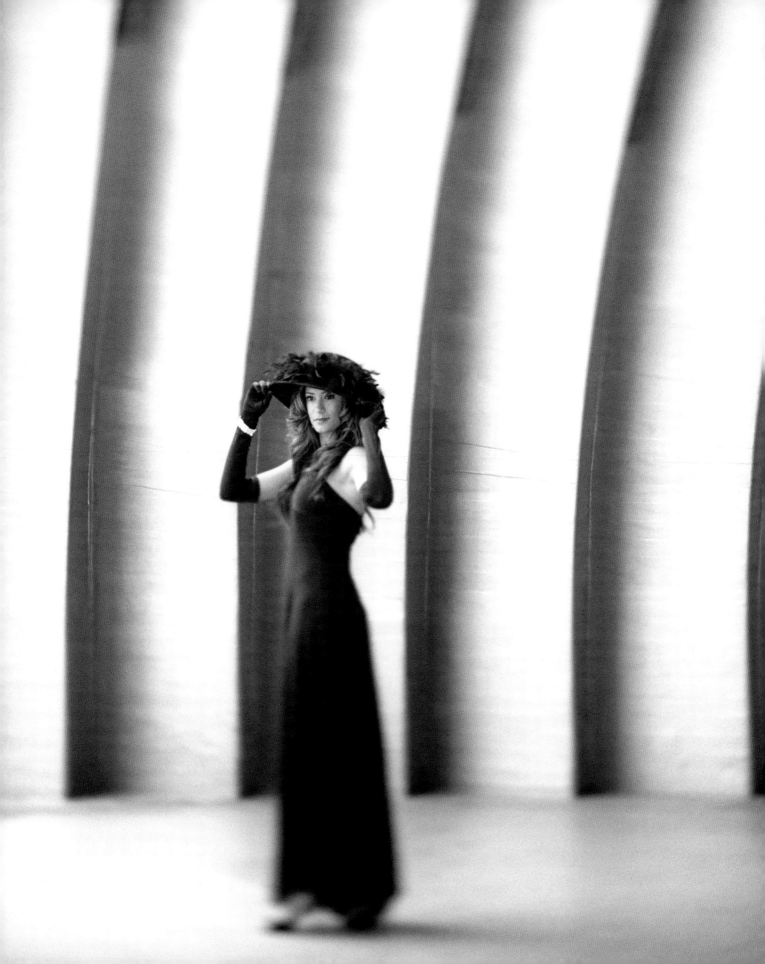

THEME:
KITSCHY 1950S COUPLE

This couple insisted that I meet them for our first appointment at their home. They grinned when they opened the door, and we all knew instantly where we should shoot and the theme we would use. They are avid collectors of everything from the 1950s. With all the props around their home, I became ecstatic with ideas. After the styling and wardrobe was in place, the couple fell into character effortlessly. We sure had a lot of laughs once the cameras started clicking!

LOCATION: When I scouted the location (the couple's home), I fell in love with the black-and-white checkered floor and knew instantly the shots I had in mind. I also loved their red couch (see page 32).

WARDROBE: Since the woman was a wardrobe stylist for the film industry, she already had a great collection of vintage outfits at her disposal. I simply consulted the couple on which ones I thought might photograph best. He found a suit from his father's closet, and his square-framed glasses gave life to our 1950s theme.

HAIR AND MAKEUP: For her we used an Audrey Hepburn retro look for a bit more inspiration, but the two of them didn't need much additional hairstyling. His slicked-back hair and her cropped bangs were popular 1950s hairstyles. She did her own makeup (trimming her eyebrows and choosing a traditional 1950s red lipstick), and we were all set.

PROPS: All I brought was the old telephone and a blue cupcake to match the blue cabinet inserts in the kitchen. Since he was a set builder for the film industry, the couple already had many props, such as vintage canned goods sitting on the shelf in the kitchen. We didn't need much else.

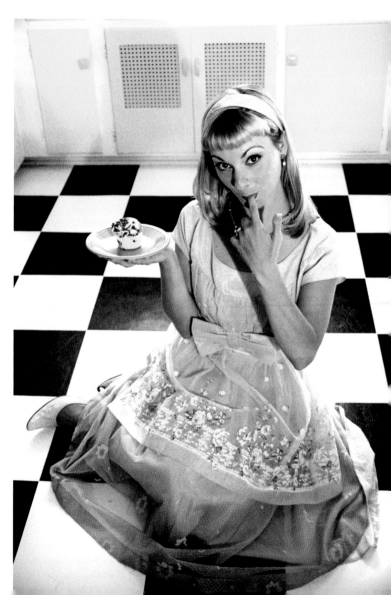

Right: To capture the fabulous checkered floor and colorful yellow and blue cabinets I had to use a high camera angle and shoot down on the couple. I positioned them in a "sweet-heart" pose commonly seen in 1950s prom pictures, and they did the rest!

Nikon F100, 28–105mm Nikkor lens, Kodak 400NC film, 160 ASA to enhance maximum color saturation, 1/60 sec. at f/5.6, Lowel incandescent hot lights

Opposite: This is my "1950s housewife gone wild" shot! The blue-sprinkled cupcake was the perfect prop to match the blue cabinet inserts in the background, and it was amusing to push the otherwise conservative vision of women in the 1950s. She really got into play-acting on this one with her provocative pose.

Nikon F100, 28–105mm Nikkor lens, Kodak 400NC, 160 ASA to enhance maximum color saturation, 1/60 sec. at f/5.6, Lowel incandescent hot lights

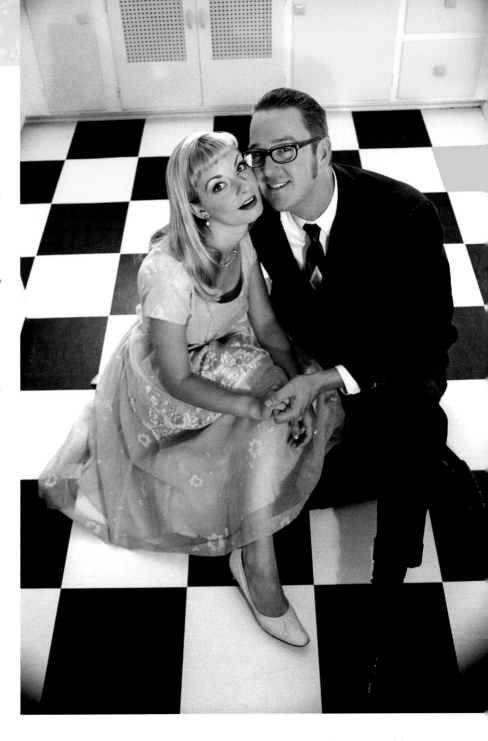

DIRECTING: I wanted to depict a stereotypical 1950s relationship, so I told them to think of the TV show *Leave It to Beaver*. We all laughed, and the couple really enjoyed hamming it up. Creating the ambiance and directing was effortlessly collaborative, and the couple really loved the images we produced!

LIGHTING CONSIDERATIONS: I used my Lowel hot lights as my primary light source. These are incandescent lights, so they tend to record a very warm (or yellow/orange) tone. To correct this, I placed colored gels over the lights to reduce some of the yellowish cast, and the lighting turned out perfectly. You can achieve the same effect with your digital camera by using the white-balance setting to color correct.

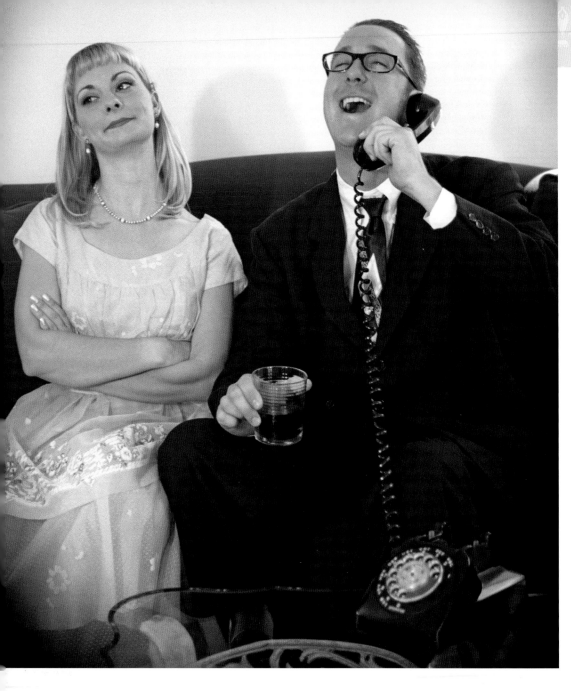

The old telephone, the Scotch glass, and the red couch were the perfect props for this image. We put our own twist on the "happy couple" concept by showing a disgruntled housewife.

Nikon F100, 28–105mm Nikkor lens, Kodak 400NC film, 160 ASA to enhance maximum color saturation, 1/60 sec. at ƒ/5.6, homemade plastic vignette, Lowel incandescent hot lights, natural ambient light

Opposite: This image was inspired by a 1950s film, *The Big Heat*, starring Lee Marvin and Gloria Graham. Natural window light provided much of the lighting for the faces. Using a white reflector gave us additional fill light for the backs.

Nikon F100, 28–105mm Nikkor lens, Kodak BW400CN film, 100 ASA, 1/30 sec. at ƒ/5.6, tripod, Nikon soft focus filter #1, natural ambient light and white fill reflector

THEME:
HITCHCOCK'S FILM NOIR

Several things inspired the theme for this photo shoot. The couple had a deep passion for old films. They both worked in the film industry, she in lighting and he in visual effects, and we shared a strong mutual affection for film noir, stylish Hollywood crime dramas that had a trademark dramatic lighting. In researching ideas, I found several great examples in a book dedicated exclusively to stills from this period, many of which were by director Alfred Hitchcock. He put his own twist on film noir with his unique lighting and camera angles. Hitchcock has been a big influence on my vintage work, and I really enjoyed getting the opportunity to recreate some of these scenes, adding my own twist on them as well.

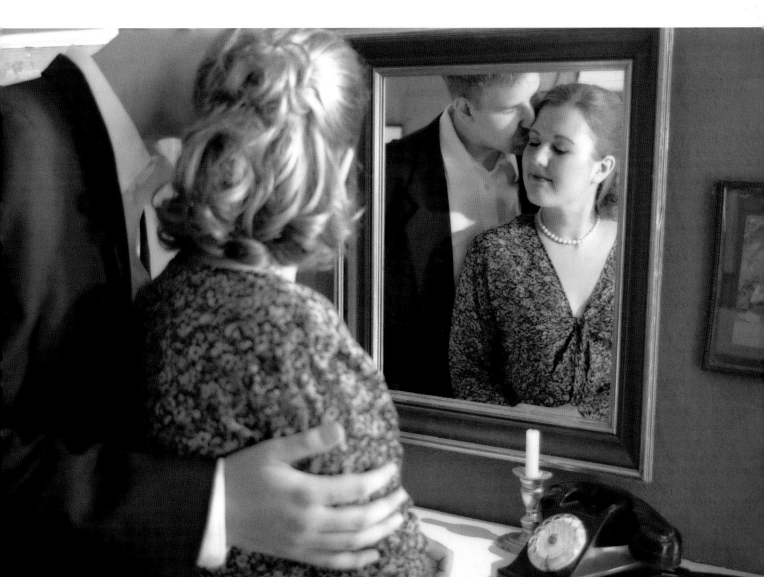

LOCATION: Perfect locales were near at hand: my home, where at the time I had a vintage mirror; a retro-inspired diner down the street; and a nearby park, where a tree faced just the right direction for a shot I had in mind.

WARDROBE: We kept it simple. He wore a simple dark suit he already owned, and she wore a flowered dress and pearls from her grandmother's closet.

HAIR AND MAKEUP: We had her hair curled, and he was lightly groomed.

PROPS: A few of my own antiques and the table settings at the diner were all we needed.

DIRECTING: Since this couple was very relaxed with each other, we chose some very relaxed poses from ideas on my shot list. All I had to do was direct them into position. Shooting in the café was a bit more complicated, since we didn't have permits and were photographing during business hours. We tried our best to be as discreet as possible. I coached the couple on what to do before we entered the café, and then we positioned ourselves accordingly.

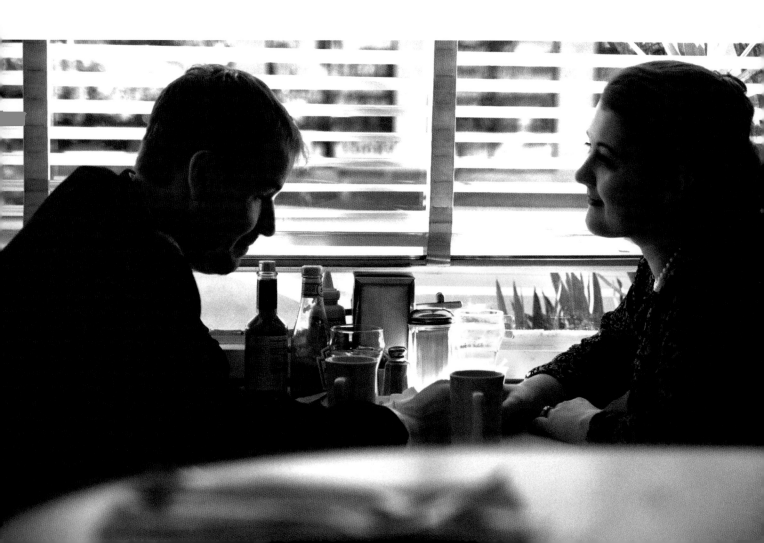

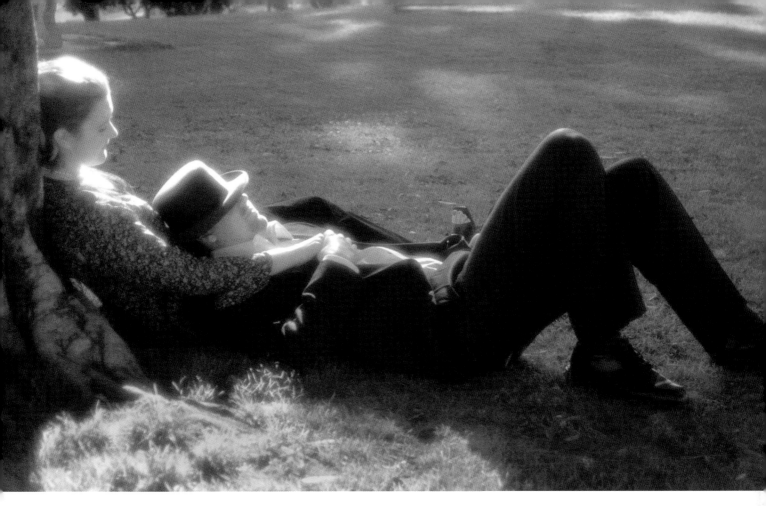

Opposite: ThisThis image was inspired by a 1940s film, *Fallen Angel*, starring Charles Bickford and Linda Darnell. Because the café was crowded and we didn't want to disturb customers or draw any attention, I had to lay my camera on the adjacent counter and secretly snap this shot.

Nikon F100, 80–200mm Nikkor lens, Kodak BW400CN film, 100 ASA, 1/60 sec. at *f*/2.8, natural ambient light

Above: This image was inspired by a 1940s film, *Out of the Past*, starring Robert Mitchum and Virginia Huston. The strong, late-afternoon backlighting provided the perfect rim light separation between the subject and the background. To keep clothing clean and dry, we brought a small black blanket for the couple to lie down upon (hidden beneath their bodies).

Nikon F100, 105mm Nikkor lens, Kodak BW400CN film, 100 ASA, 1/250 sec. at *f*/2.8, Tiffen #25 red filter, Nikon soft filter #1, natural ambient light

LIGHTING CONSIDERATIONS: For the park and café images we were careful to scout each location numerous times to confirm the exact time for the best natural lighting. I wanted to re-create a moody scene with strong back lighting and deep shadows—both trademark lighting for classic noir films. I knew shooting in these locations would require me to lean heavily on natural lighting, since using superpowerful artificial lighting was almost impossible.

THEME: SWEETHEARTS

This couple knew one another for many years, so I wanted to show a relaxed familiarity between them. What's more comfy than going to a movie with someone you love? Of course, a night at the movies is still a popular date, but it was especially so during the Golden Age of Hollywood in the 1930, 1940s, and 1950s.

LOCATION: When I found this art deco movie theater in a small town nearby, I knew I had the location for the shoot.

WARDROBE: The couple chose to wear black attire. It worked really well against the textured backdrops of a brick alley and the movie theater.

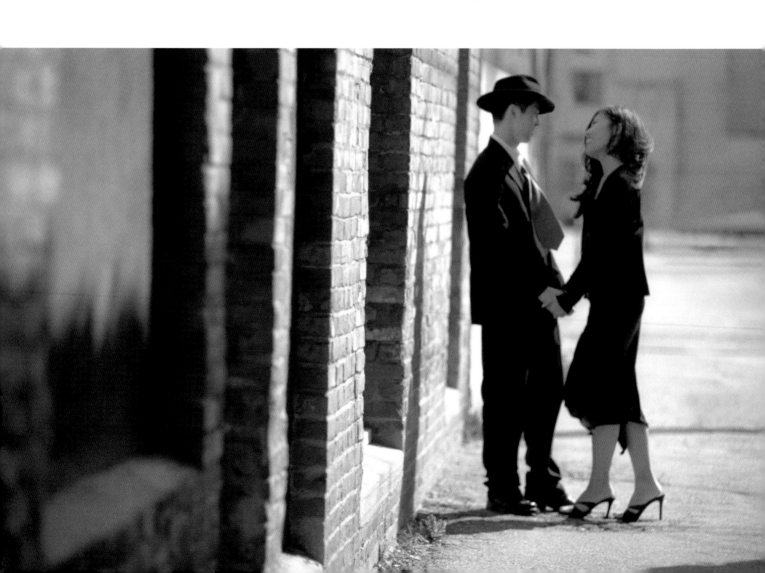

HAIR AND MAKEUP: We tried different hairstyles for her, but she just wasn't comfortable with a high-styled 'do. We compromised and opted for a soft, light curl, then used light hairspray to maintain the hair when the wind picked up.

PROPS: The location and attire provided all the atmospheric elements necessary to stylize this shoot, so additional props were unnecessary.

DIRECTING: I showed the couple sample ideas from my idea binder (see page 40), and they knew exactly what I wanted for each particular setting. They totally got into character, and this made directing them easy. To relieve any stiff or contrived poses, I spontaneously asked them to look at one another and think about how great the wedding day would be. They grinned and nuzzled, and I captured something very authentic. It was perfect.

LIGHTING AND CONSIDERATIONS: Shooting in late afternoon gives the best light, because it's soft and renders everything perfectly. My trademark style is backlighting, positioning the couple with the sunlight behind them. This creates a beautiful rim light behind the subjects' heads that separates them naturally from the background. No fill light is required if they are facing each other in profile.

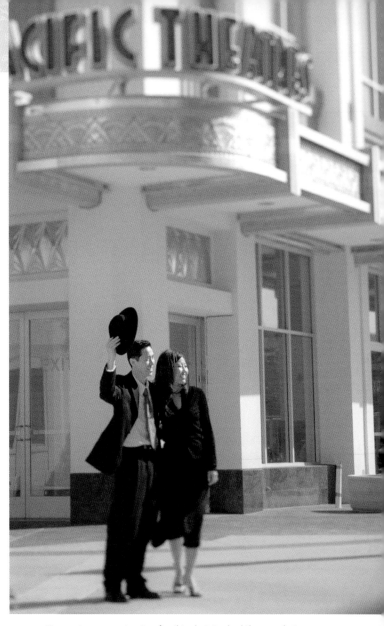

To create some animation for this shot, I asked the couple to look off-camera and I directed the man to wave his hat to an imaginary friend passing by. The wind picked up at just the right moment to create a little more movement in the woman's hair and the couple's clothing.

Nikon F100, 85mm PC Nikkor lens, Kodak BW400CN film, ASA 100, 1/125 sec. at f/2.8, Tiffen #25 red filter, natural ambient light

The sweethearts enjoy a moment of romance in a nearby alley. They really loved these intimate images.

Nikon F100, 80–200mm Nikkor lens, 1/125 sec. at f/5.6, Kodak BW400CN film, ASA 100, natural ambient light

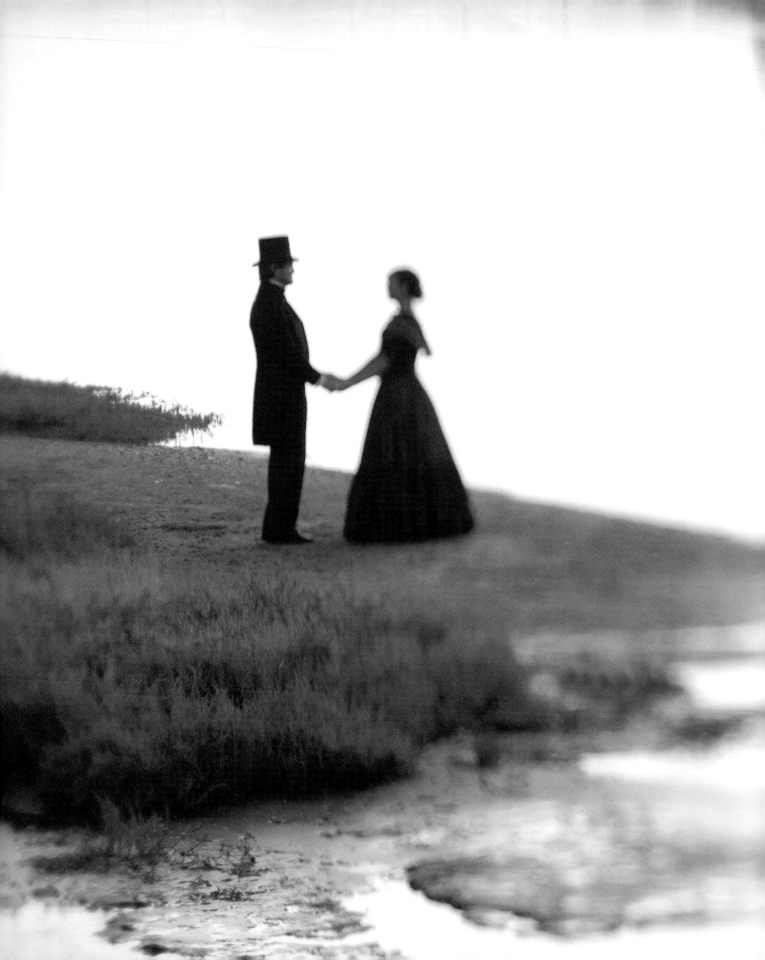

Chapter 3

RESEARCHING THEMES AND SCOUTING LOCATIONS

Your work on the engagement session begins long before the shoot. This is the time when you get to step into the role of production designer—choosing the right theme, location, props, hair, makeup, wardrobe, compositions, and expressions that best suit the couple's personality. Dream big, stretch far; allow your imagination to wander off the expected path. Don't be afraid to make some adventurous suggestions. While your clients may have ideas of their own, they'll count on you, the photographer, to get them excited and put it all together. With proper planning, you just might create some of the most amazing images of your career!

BUILDING IDEA BINDERS

Reference materials are important in preparing for the shoot. I am always looking for new ideas. Sometimes they come to me from scenes in movies. Other times, I will see images in magazines like *Vanity Fair*, *Oprah*, *Marie Claire Maison*, *People*, and *Western Interiors*. I love catalogs like those from Pottery Barn or Abercrombie & Fitch. I'm always staring at lighting, compositions, clothing, and expressions—and these aren't necessarily images of couples, but I can gain ideas nonetheless.

Keeping these ideas organized will help you keep track of them and translate them into your images. For any engagement session, I suggest creating a few three-ring binders with clear plastic sheet protectors. These enable you to insert and remove images and ideas as needed.

The first binder is labeled "Engagement Shoot Ideas." I've had a binder like this for years. I'm always collecting ideas, and this is where I store them for future shoots. It contains sample images from magazines, pages from old books, printouts from websites, and sketches of shots I might have in my head. For easy reference, I use page dividers with tabs and create categories such as Hair, Makeup, Props, Wardrobe, Themes, Compositions, Poses, and Lighting. I then create subcategories: Male, Female, Couple, and Details. Each of these might contain close-ups, traditional poses, creative poses, and mid-length and broad compositions.

The second binder is labeled "Locations" and is filled with shots of different locations, both natural and structural (such as brick buildings, dusty alleyways, cobblestone streets, a dirt pathway into the forest, prairies, ranches, vineyards, parks and canyons, tree-lined streets, general architecture and buildings, and historic landmarks). It also has a miscellaneous category for odd places, such as an abandoned gas station, a rusty fire escape, a 1950s bowling alley, a historic horse stable, and the like. I always note the date and time of day

Opposite: My idea binders often include suggestions for lighting. Overcast conditions can produce soft, romantic light that's perfect for an engagement shoot.

Nikon F100, 85mm Nikkor lens, Kodak BW400CN film, 100 ASA, 1/60th sec at f/2.8, natural ambient light, white fill reflector

Below: The three-ring binder makes it easy to add or remove reference images you have been collecting for a particular shoot. Separate them into categories like Props, Hair, Makeup, Wardrobe, and Location. You can also include additional sketches or notes for special equipment or accessories you may need, depending on the location you have in mind (maybe a stepladder or wetsuit).

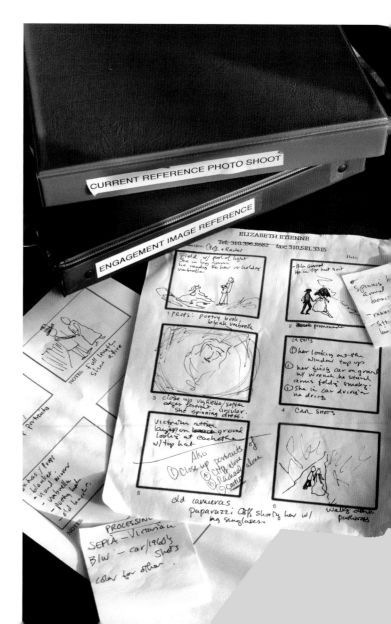

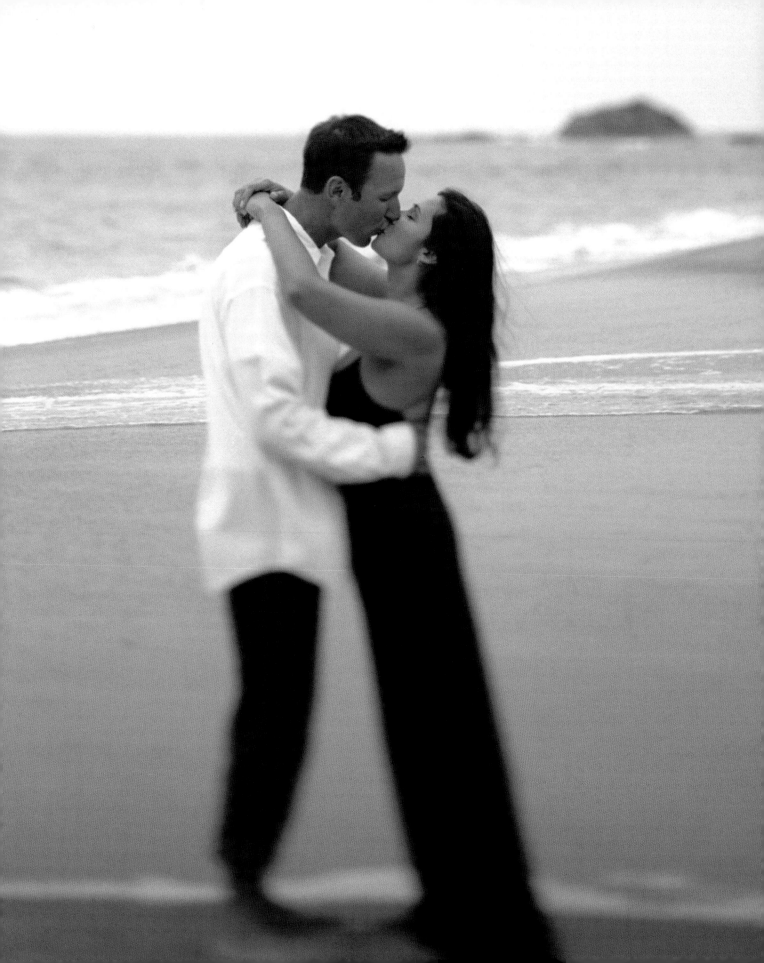

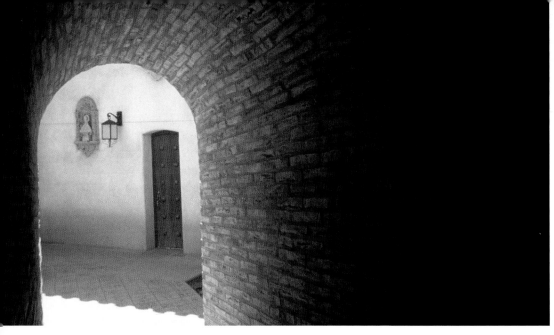

When I came across a brick tunnel near a Spanish style cathedral, with a beautiful play of light, I knew the location would be perfect for a portrait session.

Nikon F100, 28-105mm Nikkor lens, Kodak 400NC film, 200 ASA, 1/125 sec. at ƒ/5.6, natural ambient light

I took the shots in this binder, because light will fall in different places at different times of year. I keep my eyes open when I'm driving around and grab a snapshot with my camera phone or my digital pocket camera. It doesn't matter where you live; there are always interesting, funny, unusual, or sentimental locations all around you. Just look.

A third binder is labeled "Current Shoot Reference," used only for the current session I am prepping to shoot. I include ideas and images from my general "Engagement Shoot" binder, my own images from previous photo shoots, and any new ideas I may have. I also include images from my "Locations" binder. These include proof sheets from the locations of my choice. Whether these locations are new or ones I have already scouted, I always revisit them again a week or two before the shoot to confirm the existing lighting conditions and make sure nothing has changed logistically.

This binder has the same category page-divider tabs as my general "Engagement Shoot" binder (Hair, Makeup, Props, Wardrobe, Themes, Compositions, Poses, Lighting, Locations, Male, Female, Couple, Details). I try to include a variety of poses, expressions, compositions, and details, such as hands, lips, eyes, and feet. This gives dimension to the session.

Once you've gathered your ideas, confirm them with your clients. If I don't meet with my clients in person, I'll e-mail them low-resolution image samples for reference. This ensures that we're all in accord for the style and theme of the shoot.

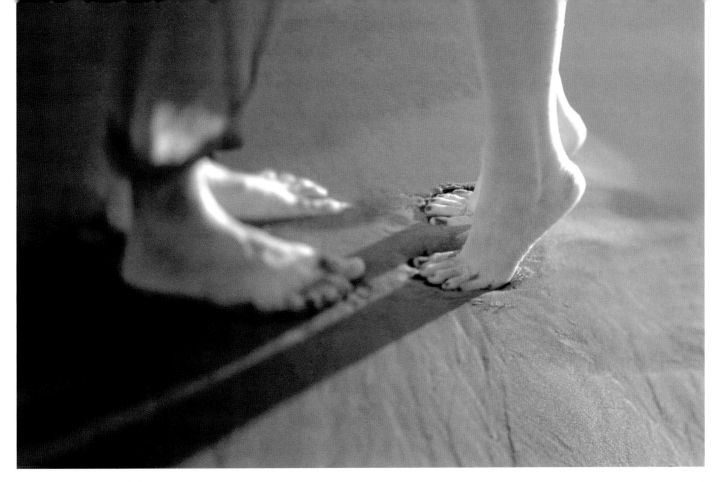
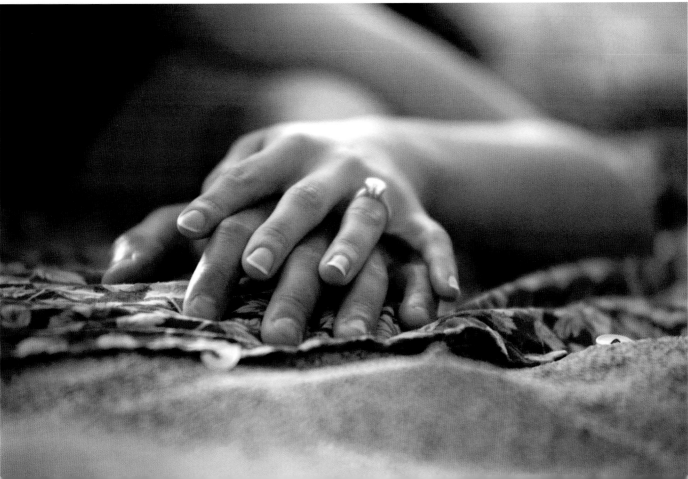

CHOOSING A THEME

Choosing the right theme is crucial to the success of an engagement session, and only one consideration really matters—that the theme reflects the couple's personality. If a couple does not feel comfortable with the location, clothing, props, and poses, their lack of ease will show in the photos.

A theme is a narrative element that prevents the images from being static and indicates the direction and style of the shoot. Working without a theme is like trying to navigate a boat in the fog at night. The theme style is usually based on the couple's personality (causal and fun or serious, conservative, and refined) or a location (a park, beach, or an art deco building).

Couples will sometimes enthusiastically tell me what they have in mind, and we'll build on that. Often, their notions are based on sentiment: They will want to shoot the engagement session on the beach where he proposed or base the shots on their shared interest in old films.

At other times, a short interview will reveal the common interests and help determine the direction, look, and feel of the session. I often give the couple a questionnaire that will help ensure a flow of ideas.

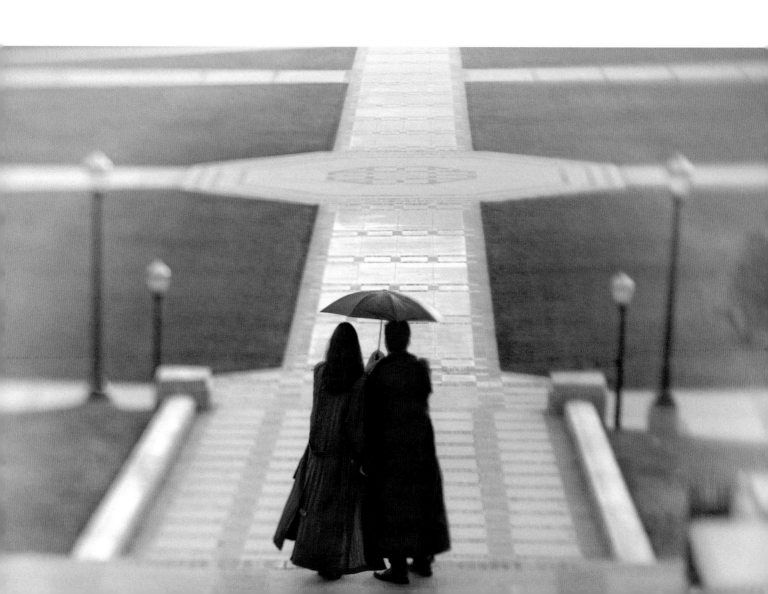

THE ENGAGEMENT SESSION QUESTIONNAIRE

The Engagement Session Questionnaire helps you get to know a bit more about a couple. It's extremely useful if a clear-cut idea for a theme doesn't present itself. I either go over the questionnaire with the couple when we meet in person or I'll e-mail it to them once we've confirmed the shoot. Here are some of the questions I usually ask:

1. Do you have any hobbies?

2. Do you have any common interests?

3. How and where did he propose?

4. What is your home design like?

5. Do you have pets? Classic cars? Instruments?

6. Who is your favorite actor, model, and TV character?

7. Is there anyone who you would secretly like to be?

Plan B comes into play when the weather doesn't cooperate with all the arrangements you've made for an outdoor shoot. In this case, a little rain actually worked to our advantage. Umbrellas, raincoats, elaborate brickwork, and appealing lamp-posts all lent visual appeal and a nice atmosphere to this image.

Nikon D700, 85mm PC Nikkor lens, 1/200 sec. at f/2.8

LOCATION SCOUTING

Whatever location you choose, it is important to scout out the setting as close to the shoot date as possible. This enables you to analyze the natural light, the direction it is coming from, where it falls, and its overall quality during your shoot. An assistant or other companion can act as a stand-in for the models. This will help you determine the best lighting and the best poses. Sometimes you'll determine that a location calls for artificial light, that you can use only natural light, or that you'll need a combination of the two (see chapter 6).

Take digital snapshots or make quick sketches to use as reminders for specific ideas, and make notes of additional gear, props, and equipment you may need to achieve the look you're after.

Back at the office, process the digital files and create proof sheets from any snapshots you've taken. Put them, along with notes you've made, into the binder for that particular job.

Having a plan B is imperative. While you might try to reduce as many unforeseen obstacles as possible, some circumstances are outside your control. (What if it rains? What if it's cloudy? What if there is road construction or a car is parked in front of the location?) Always have an alternate location (and an umbrella and extra raincoats) just in case.

I once shot an engagement shoot during the rain. I always check the weather forecast the day before a shoot. This time, the forecast was for light showers, so I phoned the couple to alert them. The couple had very hectic lives with busy careers and had been planning this session for months. They had no other free time before the wedding, so this was the only date they could do the shoot. Fortunately, I had found some covered areas to shoot and considered some of the shots we might be able to do with umbrellas. I quickly

and enthusiastically reassured the couple that we could still do the shoot and suggested we do some scenes from the classic films *Mary Poppins* and *Singing in the Rain*. They laughed and the tension broke. The images turned out great, and the couple really loved them. Thankfully I had a plan B in place.

Most communities have rules and regulations pertaining to photo shoots on public property, so check with your town's city hall to see what permits might be necessary. You are often not required to obtain a permit for noncommercial shoots, but make sure in advance. Big lights, stands, generators, and gear tend to attract police officers and park rangers, who will ask to see your permits. You'll want to have a response ready. Often it's simply a matter of explaining that you're shooting an engagement session and not something for advertising or commercial purposes.

THE STORYBOARD

When I don't have my camera with me and am not working from an image I've seen in a magazine or someplace else, I'll make sketches of ideas I have in my head for specific shots. I use preprinted storyboard sheets. Sometimes I'll make just one or two sketches, and other times I'll make a series of sketches—each sketch is like a frame in a short film. I approach many of my engagement sessions as if I were directing a movie, documenting the opening scene's establishing shots and then zooming in and out for details, pauses, tension builders, and the story climax.

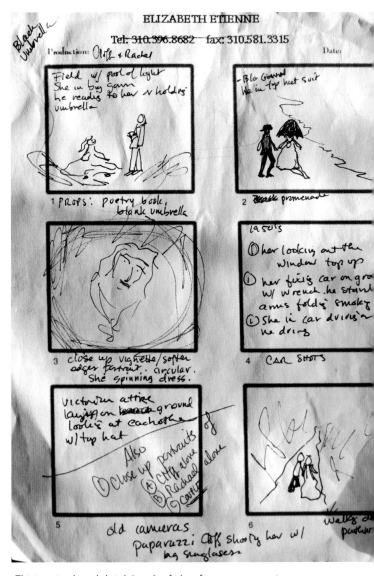

This is a storyboard sketch I made of ideas for an engagement shoot. You don't have to be an accomplished artist to sketch ideas in this way.

THE SHOT LIST

I create a general shot list, starting with the more general, simple, traditional images first and ending each shoot vignette with the creative images. I'll make notes of lenses to use, film or digital, black and white or color, vertical or horizontal, composition, focus, wardrobe changes, and props. A condensed version might look something like this:

Cliff & Rachel eng shoot: May 21st

- Couple at canal fence railing: B/W film

- Broad shot, horizontal, off-center composition: cheeks together looking into camera, shift focus from couple to fencepost at edge of frame

- Close-up of man kissing top of woman's head (profile, silhouette, soft focus)

- Details: His hand reaching for hers (B/W film, horiz)

- Couple at creek: Color desaturated (digital, B/W film, 85mm lens, stepladder)

- Broad shot: reading poetry to her, kneeling to kiss her hand

- Standing with umbrella: silhouette from behind

- Facing each other holding hands: silhouette (color and B/W film)

- Dancing

- Details: color and B/W, 85mm PC lens

- Close-up: poetry book (horiz), man's top hat, and old lamppost (vertical)

- Woman at creek: long shot, color digital, 210mm lens

- Dancing, spinning dress around

- Man at creek: Standing with cane looking into camera, stoic portrait

- English garden entrance: Woman: B/W film w/red filter

- Headshot: Hollywood glamour portrait in dappled light against wall

- Close-up of eyes looking into the light off-camera (horiz)

- Full length standing in doorway of her in dress #2 (color digital)

- Man: Leaning against wall at old home in suit #2 (woman out of focus in b.g.)

- Close-up of face looking into camera and off-camera

- Details: Roses in garden (color digital, 105mm lens)

- Garden gate (85mm lens, color film)

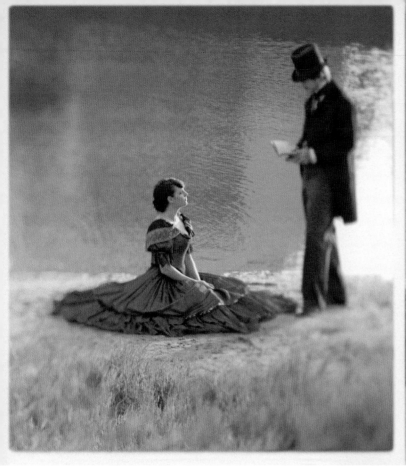

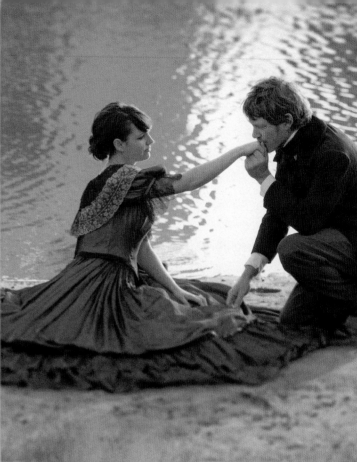

This is the realization of the image I created from the story-board sketch. Period films by director James Ivory inspired this shoot theme. I call it *Lost in Time*. I wanted to capture the romantic formality of the courtship of two lovers during the 1800s. The wardrobe and umbrella were used to enhance this time period. The story opens with a beautiful woman dancing freely by a deserted creek. A man sees her and joins her in the dance. After the dance, he convinces her to take a stroll with him along the creek, protecting her porcelain skin with an umbrella. Later they pause to rest and he tries to seduce her by reading aloud (camera zooms in for close-ups of the book). As he departs he kneels down to kiss her hand farewell, and she is clearly smitten by his charming advances. As the weeks pass, close-ups of her alone show her dreaming of him and that romantic day they spent together. Portraits of him show his aristocratic poise. Finally the two meet again. This time he embraces her by kissing her on the head, and she melts in his arms. The story ends as the two lovers walk off into the sunset together.

Top: Nikon D700, 85mm PC Nikkor lens, ISO 200, 1/500 sec. at f/2.8, natural ambient light

Bottom: Nikon D3, 85mm PC Nikkor lens, ISO 320, 1/750 sec. at f/2.8, natural ambient light

Opposite: Nikon F100, 85mm PC Nikkor lens, Kodak BW400CN film, 1/500 sec. at f/5.6, natural ambient light

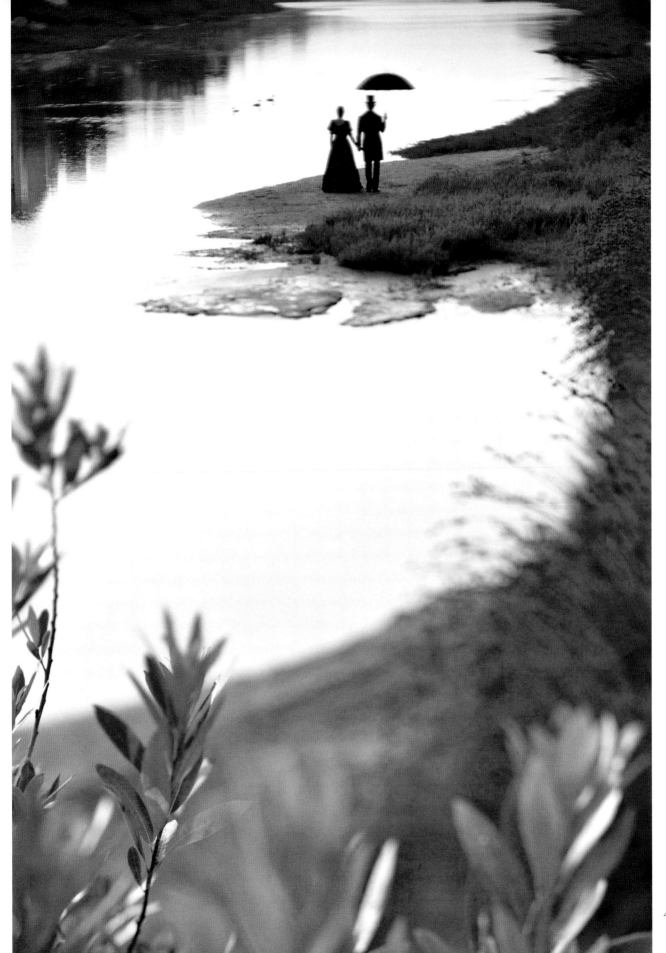

Chapter 4

PREPPING FOR THE SHOOT

Being a successful engagement photographer requires that you feel confident about yourself and your work and know that you will produce a great shoot. Technical expertise and organization come into play to ensure that you have the right gear and know just how to use it so you never miss a memorable shot. Organizing your equipment so that it is readily at hand and making sure it is all in top operating condition are also part of mastering a shoot and fulfilling your greatest asset as an engagement photographer: your unique vision.

Mental Preparation

When shooting an engagement session, you need to feel confident and positive, even if you're not in the mood to shoot that day, not feeling as energetic as you might, or have something else on your mind. The best advice is to take ten or twenty minutes before the shoot to write some affirmations (the way a performer does before going on stage or an athlete might before going out on the field). Imagine you have an Olympic coach next to you and are routinely prepping for the next race. Envision the images you are going to shoot, how you will feel shooting them, how your subjects will feel being photographed, and what their response will be afterwards. Try something like this:

I am an amazing photographer!

My work is outstanding!

People love me and love to be around me.

I make them laugh and cry with my great images.

Making great images is fun.

I can see people looking at them afterward, smiling at how fun they are since I captured just the right moment.

Today I will make the best pictures of my career!

My images will be new, different, and incredible—the most beautiful, soulful, romantic images I have ever created!

I am focused, totally present, creative, confident, and in control.

SCHEDULING THE SESSION

Unlike photographing the wedding day, you have some flexibility when doing an engagement shoot. For you, the photographer, the sooner you can do the session before the wedding, the better. This will give you more time to process and retouch the images and then sell your clients many of your a la carte products (gift cards, framed photos, slideshows, and other products derived from the shoot).

Some clients may even opt to have their session after the wedding, when they have more time and feel less stressed. For them, the engagement session is a chance to get some informal, candid images.

PHOTO ASSISTANTS

Choosing the right crew members to represent you and your business is important, because they are a reflection of all that you are and what you offer. You want people who are clean, professional, and respectful. I usually work with two assistants: The first assistant is responsible for the gear, and the second assistant helps him or her. They carry all the equipment and give me what I need when I need it. On shoots with bigger budget, I have a production manager who organizes all crewmembers. These could include a hair stylist, makeup artist, wardrobe consultant, prop master, and photo assistants. The production manager also coordinates the scheduling for the crew and client, arranges food and beverages, and handles any transportation, location, or logistical challenges. The production manager also may be responsible for the shot list to ensure that each intended shot is covered. This enables assistants to focus exclusively on the gear and the technical aspects required for making each shot work.

Assistants should arrive about an hour before the clients do. This gives them time to prep the gear and review the current shoot reference binder (see page

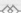

40) and composition shot list (see page 54) to make sure you haven't forgotten anything. Remind them of the clients' names and some minor background info about them. This will enable them to address clients respectfully when introduced. Assistants should always be businesslike but friendly when they meet your clients. They might say something like, "Hi, Karen and John. I have heard so much about you. We are really excited for the shoot today and know were going to make some incredible images!" This immediately sets an optimistic and personal tone.

Can You Get By Without an Assistant?

The answer is NO! Never do a shoot without one (no matter what it costs). Even if it means breaking even on the shoot because you have to pay your assistant, do so. If you lose money to pay your assistants, do so! Not only do you need an extra set of hands to pass you a lens, prep for the next shot, and communicate with the couple (especially in cases where you might be shooting with a long lens from afar), but working with an assistant also gives you a more polished, competent appearance. It's hard to look professional when fumbling for a lens, flash, digital card, camera body, or reflector card while trying to coordinate the shot at the same time! An assistant enables you to make better images, and better images will bring you more jobs and a higher pay scale. Besides, assistant fees are low, approximately $75 to $200 for a session, and many assistants will work with your for free just for the experience. You might consider a trade—you and another photographer can agree to assist each other on shoots.

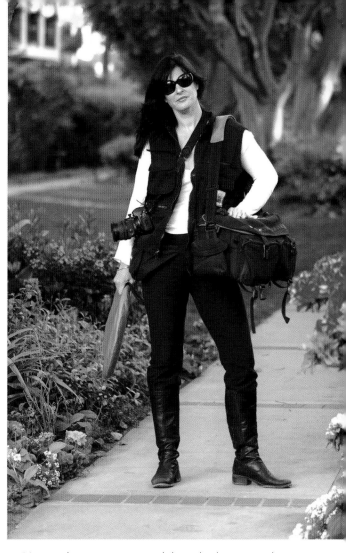

My second assistant is wearing a lightweight photo vest and fanny pack purchased at an army navy surplus store. Extra lenses are stored in the photo vest pockets and cameras, back-up flashes and lenses are stored in the shoulder camera bag. A surplus of film, memory cards, batteries, and smaller items are carried in a fanny pack. She is also carrying a reflector that is gold on one side and white on the other. Reflectors render a beautiful kind of light that is much different than flash lighting.

THE SHOT COMPOSITION LIST

You or your assistants should keep a copy of a shot composition list in your photo vests. This list reminds you to shoot a variety of compositional versions of the same image setup. It will include horizontal and vertical images, both color and black-and-white images, center-balanced and off-balanced compositions, and both creative and traditional compositions. In my early days of shooting, I was so eager to shoot my creative trademark images that I would completely forget about traditional images of the couple looking into the camera smiling. These are the ones the bride and groom's parents usually order and frame. I now have my crew or production manager remind me to make sure we shoot those traditional images first and the creative ones second.

Obviously, shooting the creative images is more fun, but you can vary traditional images by having the couple looking off-camera instead of looking into the lens for a few frames. You might also shift the focus from their faces to an object such as an iron gate or tree branch for variety. Having a wide variety of images ensures that you will have the image the client will want for a particular frame dimension or that a magazine or stock agency might want for a particular layout. In the back of your mind, you should always be thinking about how your images might be recycled beyond the present photo shoot. This is imperative to residual income sales. If a stock agency requests variations of a great image (vertical, horizontal, left/right balanced, or black and white) you want to have it.

Assistants should also have your image reference binder at hand (see page 40). Having a image reference binder eliminates any anxiety or head scratching for ideas: You can simply repeat variations of the test images you did when location scouting. Spontaneous, unplanned shots will also come to mind, and they are part of the fun and often your best images. But having some guidelines to follow reduces the pressure and ensures you get the images you want.

Here is a typical shot composition list:

➵ Color images

➵ Black-and-white images

➵ Vertical images

➵ Horizontal images

➵ Individual portraits: creative and traditional

➵ Couple portraits: creative and traditional

➵ Fun/happy images

➵ Serious/intimate images

➵ Close-up—couple and individual portraits

➵ Mid-length—couple and individual portraits

➵ Far away—couple and individual portraits

➵ Detail shots, including location details, to tell the story—might include body parts (hands, feet, eyes, toes, lips, etc.)

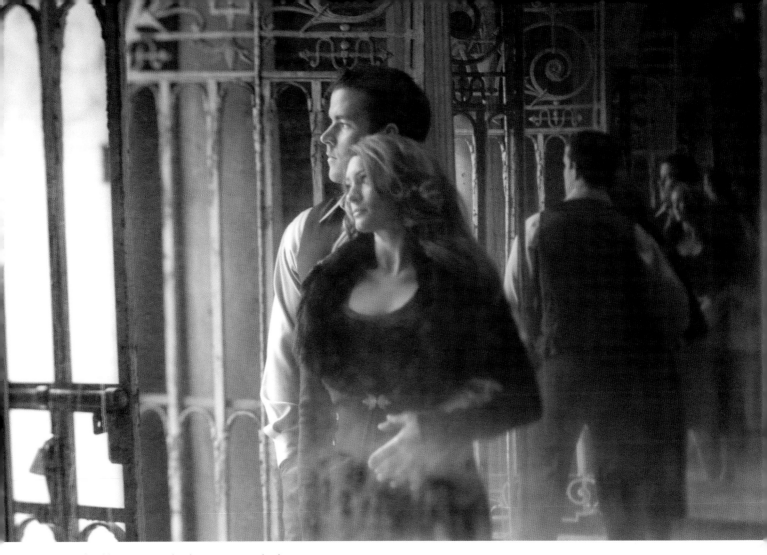

By creatively adding variety to the shoot, you can make the images more marketable for stock and advertising. Try having the couple look off-camera and work in interesting architectural details.

Nikon F100, 85mm PC Nikkor lens, Kodak 160NC film, 100 ASA, 1/125 sec. at *f*/2.8, natural ambient light

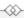

Practicing for the Shoot

If you feel nervous about your first paid engagement shoot, do a test session with your assistant or a friend and let loose! It doesn't have to be a romantic shoot, but you will want to treat it in the same manner by location scouting and preparing in the best possible way. Explore every possible lighting situation and frame composition. See what looks best. After a few practice runs, you will acquire the confidence needed to make your first shoot with a client a success.

GEAR

The main rule for an engagement shoot is to keep it simple: Consider equipping yourself with two digital cameras and, if you use film, two film cameras (in case one fails); two portrait lenses (any lens that ranges from 70mm to 200mm and a 105mm F 2.8 lens), a wide-angle zoom (28–105mm), a fixed wide-angle lens (20mm), a reflector disc, two flashes (in case one fails), and one flash diffuser. Some pieces especially well suited to an engagement session include the following:

* A flash diffuser is like a miniature soft box for your flash head that softens the otherwise harsh effects of a flash—an inexpensive yet invaluable tool, and I wouldn't dream of shooting without one.

* When possible, a round retractable reflector disc with two sides—a warm, shiny gold and a solid white side—is preferable over a flash because it is daylight balanced, requires no batteries, and can be used wherever bright sunlight is available. It simulates a giant mirror bouncing light onto your subjects, creating a beautiful and natural appearance.

* A plastic vignette can soften and fade out edges of frames for an antique appearance.

* A tripod will probably not be necessary for an engagement session unless you are shooting in a studio or need to shoot some still-life images under low lighting conditions. A Manfrotto carbon-fiber tripod with a Gitzo rotating head is ideal because it is more durable and lighter than standard tripods. You might also consider a monopad. It's not as stable as a tripod but is lighter and easier to maneuver.

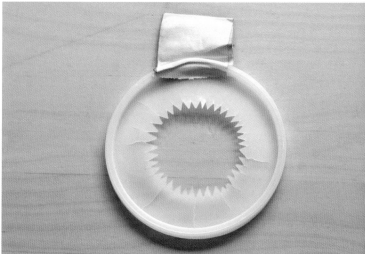

Top: Double diffuse flashes by using the diffusion cup as well as a diffusion box. The Westcott Apollo Light Modifier is like a lampshade to a raw bulb and provides a generous amount of natural looking light. When using this, overexpose the flash by one stop to compensate for the reduction in light caused by the light modifier.

Bottom: This is my crazy vignette, homemade from a plastic container lid. A piece of grip tape attached to the top allows me to hand-hold the device in front of my lens and adjust the distance so the vignette (created by the jagged hole cut in the center) falls out of focus around the edges of the image. It creates a romantic faded-image effect.

Opposite: Here's an image where the vignette adds a vintage atmospheric element to a portrait of a couple.

Nikon F100, 28–105mm Nikkor lens, Kodak 400NC film, 160 ASA to enhance maximum color saturation, 1/60 sec. at f/5.6

Cleaning and Protecting the Gear

Begin by cleaning all the camera lenses, camera bodies, filters, and flashes with canned air and a soft lens cloth. Be sure to remove any fingerprints, dust, or sand from the lenses and camera bodies, since sand or dirt can scratch the lenses and filters, grind down the lens mounts, and interfere with electronic sensors. Also check to see that a UV filter, lens hood, and lens cap are on each lens. The filter and cap protect the lens, while a lens hood reduces lens flare, which could cause a hazy, out-of-focus image. Rubber "retractable" lens hood types are more compact, lighter, and easier to use than the hard plastic models.

Packing for the Shoot

Since you'll generally require less gear for engagement shoots than you will for wedding shoots, you can probably travel light and get away with a small shoulder bag and a fanny pack. This will make it a lot easier to move around a location, especially if you're shooting outdoors, and will make it easier to be as inconspicuous as possible. The objective is to be organized so you have quick and easy access to your gear and never miss a great shot.

I usually carry just one camera with a lens over my shoulder and keep additional lenses, flashes, film, and batteries to a minimum, stored in a fanny pack or in cargo pants with lots of pockets. Obviously, an assistant is handy for carrying some of the extra gear.

➢ Label all equipment, including tripods and camera bags, with your contact information, in case you accidentally leave a piece of equipment behind. This includes the Ziploc bags you will use for new and used batteries, film, and miscellaneous electrical plugs and cords.

➢ Label digital memory cards from A to Z and use them in alphabetical order. This helps you keep track of which ones have been shot and which ones are available for use.

➢ Label the backs of film cameras as well.

➢ Bring twice as much film and twice as many digital cards than you will need, just in case.

➢ If a camera has dual memory card slots, such as those in the Nikon D3 series do, use two different brands of memory cards (in case one brand malfunctions you'll have a backup).

➢ Consider using 4G and 8G memory cards. While bigger cards are obviously more convenient, with them you run the risk of losing a large amount of images should a card malfunction. I also find that I'm more "image-conscientious" when I shoot with smaller cards. This disciplines me to shoot the allocated number of images in the client's price package.

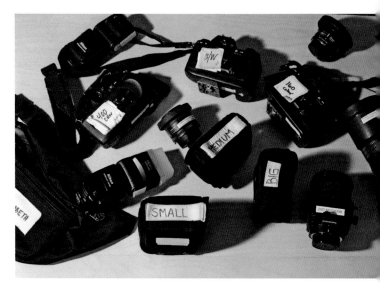

Label everything with white grip tape and a permanent marker. Also add a sticker with your name and phone number in case something gets left behind. Label camera bodies and flashes with letters (A, B, C, etc.) so you can differentiate between them easily.

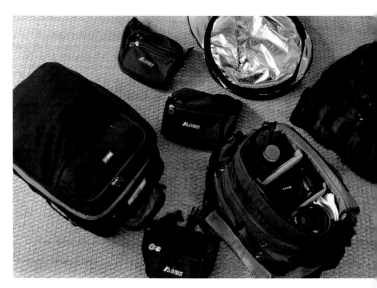

Bags, vests, fanny packs, even a big roller bag are all part of an engagement photographer's gear. For smaller shoots, a smaller shoulder bag, photo vests, and fanny packs can suffice.

Opposite: An engagement shoot may take you into many locations where you will need to have just the right equipment near at hand to capture a natural-looking shot. After a few sessions spent traipsing around a beach or other outdoor setting you'll learn the wisdom of packing lightly and efficiently.

Batteries

Remove batteries from cameras, flashes, and other equipment between photo shoots. Batteries left in an electronic device will continue to drain power (even when the device is turned off) and can corrode the contacts, especially in humid conditions. Before reloading the batteries, use a battery tester to check the remaining power. You don't want to run out of battery power in the middle of a shoot. As backup, bring one extra set of batteries per device, bundled together with rubber bands and packed in clean, plastic, Ziploc baggies. This will enable you to grab all of the necessary batteries at once and reinsert them in the device. For the cameras, preload extra battery cartridges, so you can simply remove one used four-battery cartridge and replace it with a new four-battery cartridge to save time.

Once the batteries are in place, power cameras and other devices on and test fire them a few times to make sure everything is operating correctly.

→ Because the flashes require far more power than camera bodies, use either lithium batteries or rechargeable batteries. Both are substantially more powerful and last much longer than standard alkaline batteries, but they are also more expensive. Rechargeable batteries are better for the environment, but over time they will lose their power, so have lithium batteries handy as backup.

→ Use less-expensive alkaline batteries for camera bodies and walkie-talkies, since these don't require as much power.

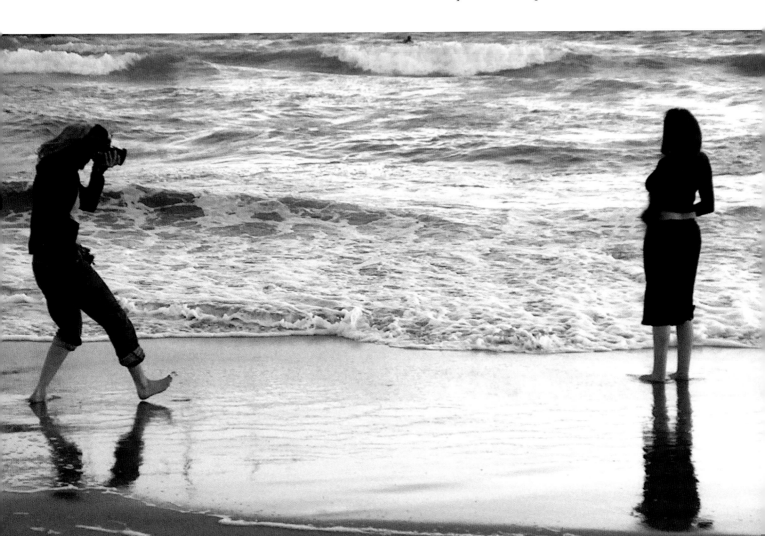

CAMERA SETTINGS

The final gear-prep task is to prepare all the camera settings. During the shoot day, you may adjust digital camera settings here and there for specific shots, but it's important to begin each shoot with all adjustments set to the zero default settings. This way, you'll have a baseline and know what's wrong if an image isn't exposing correctly.

→ **Set your camera meter to the center-weighted setting.** This setting will meter a certain percentage of the frame, usually including your main subject. So regardless of where you compose your frame, the meter will follow to where you place your focus.

→ **Set Exposure Compensation buttons to zero.** If you shoot a scene that is not exposed to your liking, you can adjust your Exposure Compensation button by +1 stop to brighten the image more or -1 stop to darken the image.

→ **Set the Shoot Mode to Aperture Priority.** I like to control the depth of field, so I set the camera's exposure mode button to Aperture Priority and then adjust my aperture where I want it. For close up portraits I usually use *f*/2.8. This throws the background and foreground out of focus so the main subject I am focusing on is prominent. I sometimes alter this to *f*/4.5 or *f*/5.6 if the couple is staggered at different distances to the lens. For group shots in which subjects are staggered at different distances from the lens, I set my *f*-stop to *f*/5.6, *f*/8, or even *f*/11 for shots at oval tables.

→ **Set Focus Tracking to Continuous.** In Continuous focus tracking mode, your camera will focus on the main subject even when in motion. Occasionally, I will switch to manual focus if my camera is having a difficult time focusing (as it might in low-light situations) or when using manual focus lenses.

→ **Set the Focus Range to Narrow.** This will make it easier to focus on the couple.

For digital cameras:

→ **Set the Image Quality to RAW.** Shooting in RAW provides far more tonal range and color information than shooting in JPEG or TIF does. This gives you far more latitude in making adjustments for exposure, color range, etc. To maximize your RAW capture quality, it's imperative to expose correctly while shooting (use the histogram to confirm your shadows and highlights ranges).

→ **Set White Balance to Auto.** The color temperature for each shot will vary depending on where you are shooting (open shade or bright sunlight). When you shoot with the White Balance setting on Auto, the camera makes the best judgments for the color temperatures for each scene. While these color temperature may not always be totally accurate or to your liking, you can adjust tonal values in post-production processing.

→ **Set ISO to 200.** I choose ISO 200 as my starting point after many years shooting in later afternoon. This setting gives me a finer grain and enables me to shoot at a wider aperture setting (i.e., *f*/2.8) in brighter-light settings. If I notice the shutter speed is too slow to hand hold the camera (I advise 1/60 of a second or faster), then I bump up the ISO until it meets the appropriate shutter speed and *f*-stop.

Opposite: Camera settings provide a great deal of creativity. Mastering them to achieve subtle effects, such as blurring the foreground to focus on this couple's tender moment, is part of developing a distinctive style.

Nikon F100, 85mm PC Nikkor lens, Kodak 400NC film, 200 ASA, 1/125 sec. at *f*/2.8, natural ambient light

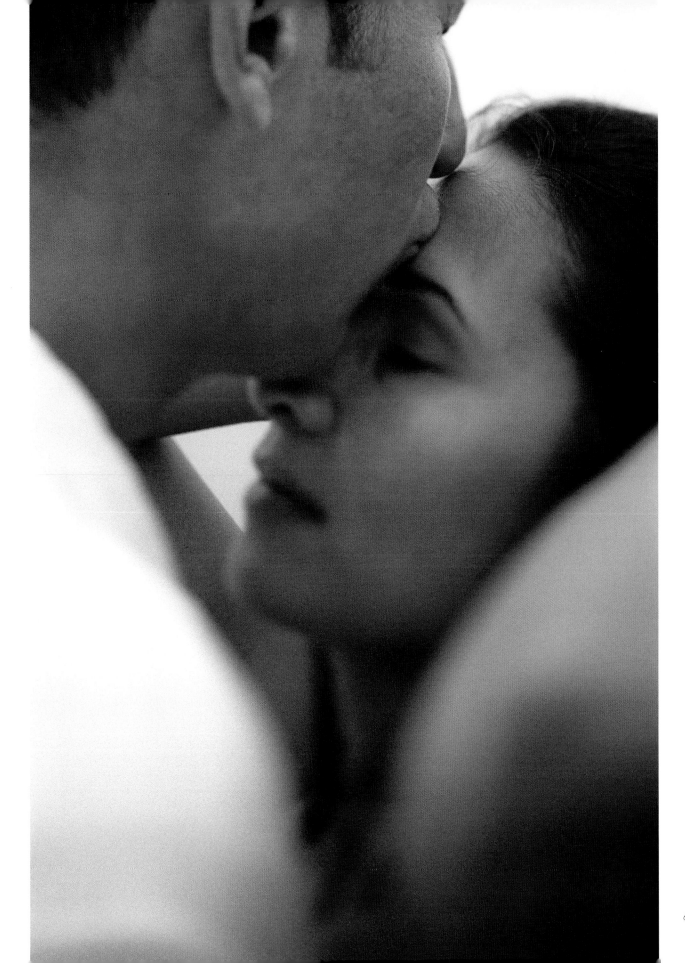

FILM

I shoot both film and digital, and each medium renders a different appearance. This enables me to not only have a variety of looks but also gives me additional forms of backup. Typically, I shoot with film to take advantage of the grain quality when I am trying to obtain a more "retro," fine-art-like appearance (usually in black-and-white images but also sometimes in color). I have also shot some more contemporary images with film, when experimenting with a moodier, different look.

I use Kodak film exclusively. I rate my 400NC color film at 200 ASA, 160NC color film at 100 ASA, and BW 400CN black-and-white film at 100 ASA (overexposing it two full stops). My lab processes the film and I convert the negatives immediately to digital files.

The BW 400CN is my favorite black-and-white film because it can be processed at any lab (pro or consumer) using color chemistry and is easily converted to digital files. If I choose to make a print from this film, it can be toned to sepia, blue, green, or red. Overexposing any of these films gives rich, crisp tones and saturated colors and enhances skin tone by reducing fine lines and blemishes, creating a very beautiful, slick look. You cannot overexpose in digital format to achieve the same effects—in fact, if you overexpose the highlights you risk losing details. It's better to underexpose a digital file slightly to retain more information in the highlights and make any necessary adjustments in post-production processing.

SHOOTING BLACK & WHITE VERSUS COLOR

How do you decide which image you want in black and white and which in color? The answer is quite straightforward. Shoot color only when the colors in a scene are dominant, beautiful, and complementary to the composition. If color is not a key to the image, shoot the image in black and white. Dramatic details,

journalistic snapshots, and fine-art or vintage-style images work especially well in black and white.

That being said, it's wise to shoot the most important key images in both color and black and white: Color images are much more desirable to stock agencies, should you decide to pursue that form of residual income. Black-and-white film images have become a fine-art novelty, should you decide to recycle your images into gallery-quality prints and pursue the fine-art world. These are considerations to keep in mind when shooting.

Portraits, in both color or black and white, give an engagement session depth and diversity. The subtle shades created by dappled sunlight made color the right choice for this shot.

Nikon D3, 85mm Nikkor lens, ISO 320, ƒ/2.8 at 1/250 sec., Tiffen 81A warning filter, natural ambient light, white fill reflector

Opposite: Black-and-white film provided just the right texture and mood for this dramatic image. Color would have distracted from the strong shapes and effects.

Nikon F100, 85mm PC Nikkor lens, Kodak BW 400CN film, 100 ASA, 1/500 sec. at ƒ/2.8, natural ambient light

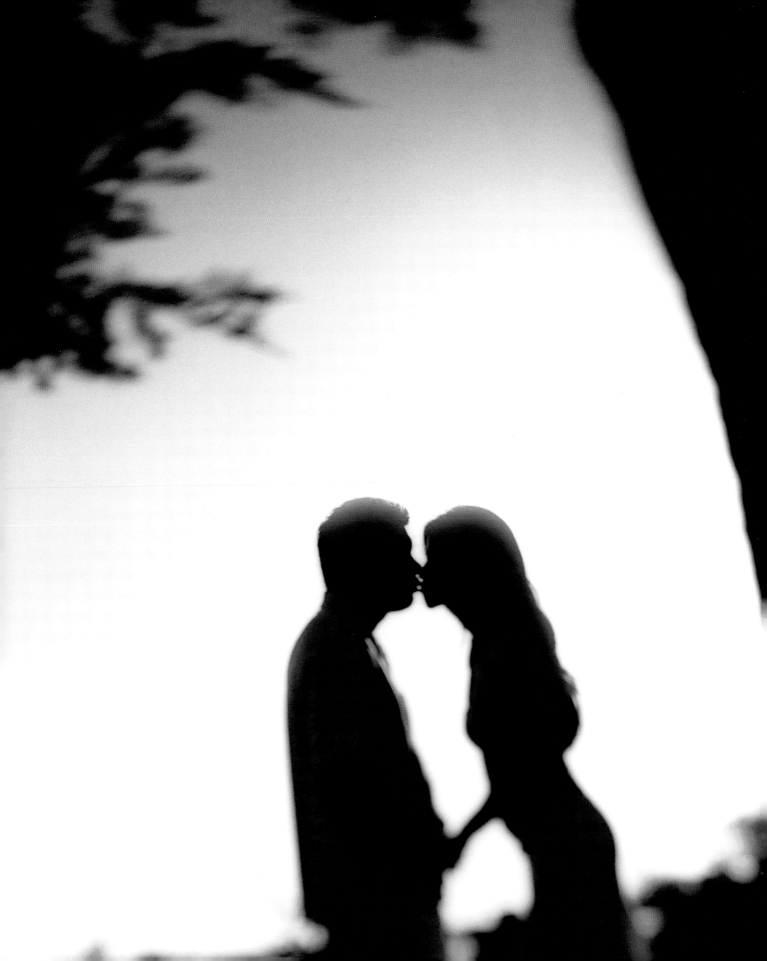

AN ENGAGEMENT SESSION . . .
in an Architectural Setting

A nineteenth-century Spanish cathedral, an art deco library, and a contemporary private residence can all be evocative settings for engagement shoots. These surroundings, with their architectural details and furnishings, are subjects in themselves and add another dimension to your portrayal of the couple. Depending on where you shoot, the setting can set a sophisticated and elegant tone or, for that matter, a casual mood.

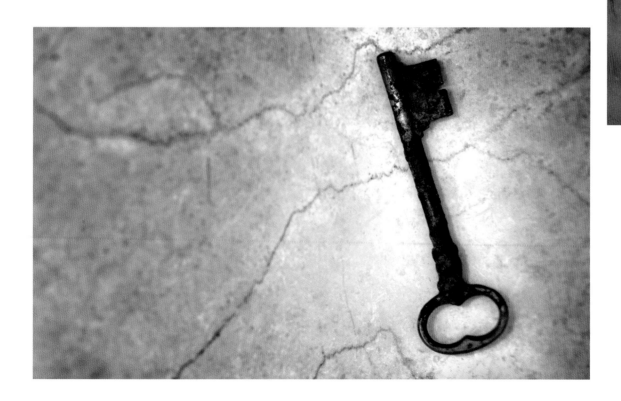

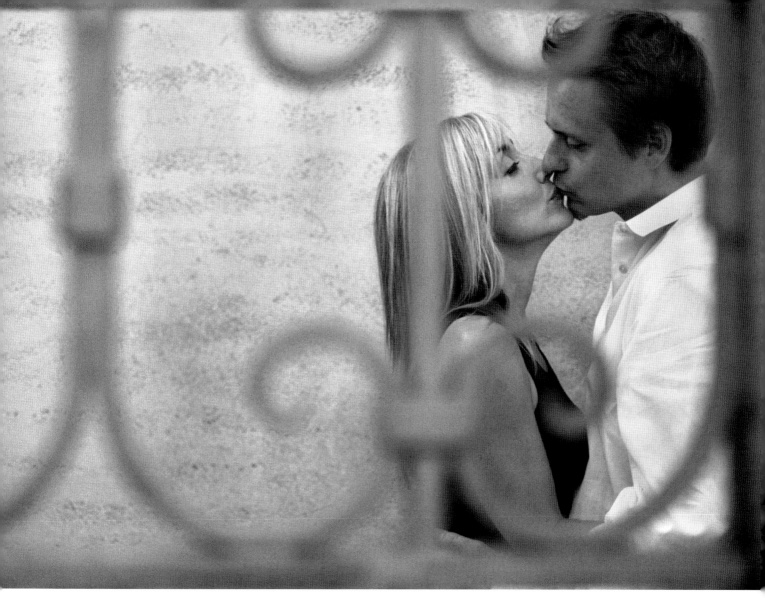

Opposite: The antique key shot against the stone marble is an appropriate prop for a shoot in an old cathedral. I used a small, oval lipstick-case mirror as a reflector to bounce a small highlight around the key.

Nikon D3, 85mm Nikkor lens, ISO 320, 1/500 sec. at *f*/4.5, natural ambient light with mirror fill reflector

Above: The iron gates provided an ideal romantic vignette for this kiss shot. Placing the couple off center and shooting with a shallow depth of field enhances the feeling of intimacy.

Nikon F100, 28–105mm Nikkor lens, Kodak BW400CN film, 100 ASA, 1/60 sec. at *f*/5.6, natural ambient light

PREPARATION AND OBSTACLES: Check into permissions well before the shoot. Owners and property managers often have strict rules about shooting on their premises and may ask you to pay hefty location or rental fees, especially if they think the images will be used in advertising to generate money. Remind them you are only shooting an engagement session for a couple—the words "engagement session" tend to loosen the reins a bit. To sweeten the deal, you might offer an exchange of images they could use for their website or for promotional purposes. If you do so, make sure your clients sign model releases. Furthermore, if you think you might want to recycle the images into stock (see chapter 10) you'll need to get a signed property release from the owner or property manager.

If you intend on shooting inside, be careful with your gear around antique furniture, hardwood floors, or anything fragile. Place old rags or towels under furniture—dragging a chair across a room can

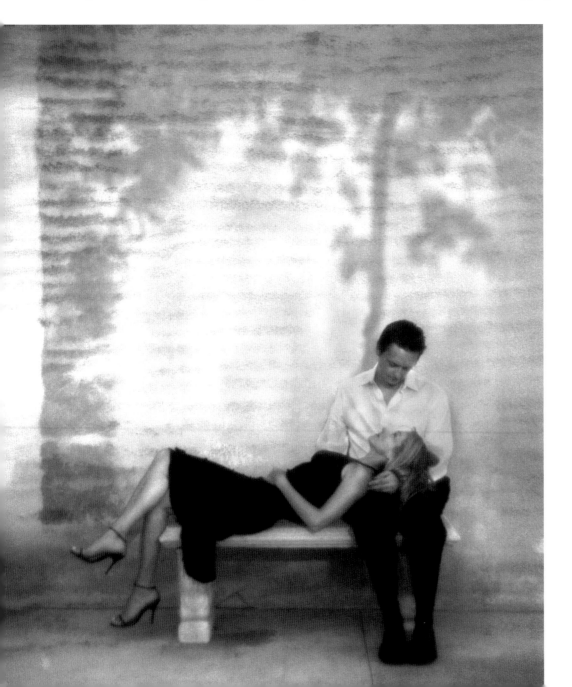

severely scratch beautiful hardwood floors, and you could end up spending hundreds of dollars to have them repolished.

If you're planning on using artificial lights, make sure all the outlets work and are capable of handling the amount of voltage required. You don't want to blow a fuse or, worst-case scenario, start a fire. If you are using hot lights, turn them off periodically to let them cool down.

WARDROBE: Architectural settings often lend themselves to formal, semiformal, elegant, or fashionable attire. Women may want to wear a classic cocktail dress and men a suit or dress shirt and slacks. If the couple has creative, artistic personalities, you might want to experiment with more fashionable, trendy clothing. A couple may want to bring a few clothing choices to see what works best in the setting.

Opposite: Shadows and patterns can create beautiful soft vignettes like this one that emerges when tree branches cast wispy shadows against an old brick wall. The couple's solid black garments were ideal for offsetting the busy, patterned wall behind them.

Nikon F100, 28–105mm Nikkor lens, Kodak 400NC film, 200 ASA, 1/125 sec. at f/4.5, Tiffen #25 red filter, Nikon soft filter#1, natural ambient light

Below: This is an example of combining a magnificent interior with a portrait. Including a close-up of this gorgeous crystal chandelier suggests a cinematic feeling of zooming in and out.

Nikon f100, 85mm PC Nikkor lens, Kodak 400NC film, 200 ASA, 1/125 sec. at f/3.0, natural ambient light

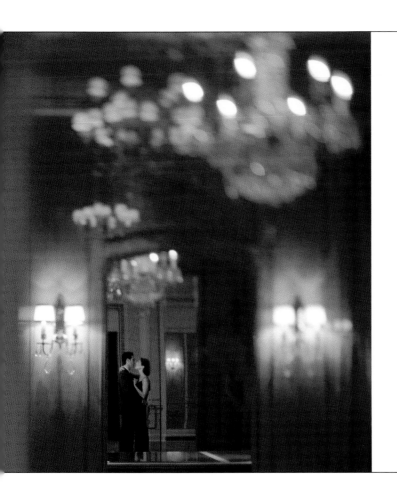

HAIR AND MAKEUP: Women will probably want a classic, elegant hairstyle—maybe a loose but controlled long wave or soft curl. Men might want to try slicking their hair back with gel.

Makeup can be a bit more dramatic than it would be for an outdoor shoot. Try a high-fashion glamour look with smoky eye shadow, defined eyebrows, and heavier-than-usual lipstick. Keep in mind that in the final images makeup never appears to be as heavily applied as it does to the naked eye during shooting (especially when you overexpose a little for close-up portraits).

PROPS: Architectural details and unique furnishings will often replace the need for any props. That said, a few unique pieces can support the theme of the location where you're shooting.

LIGHTING CONSIDERATIONS: Natural light can often create dramatic effects in architectural settings, reflecting off walls and creating interesting shadows.

This image works especially well in color because the woman's blond hair is in perfect contrast to red brick mellowed by low late-afternoon light. The couples' black attire complements the iron gates in the background.

Nikon F100, 28–105mm, Kodak 400NC film, 200 ASA, 1/60 sec. at ƒ/5.6, natural ambient light

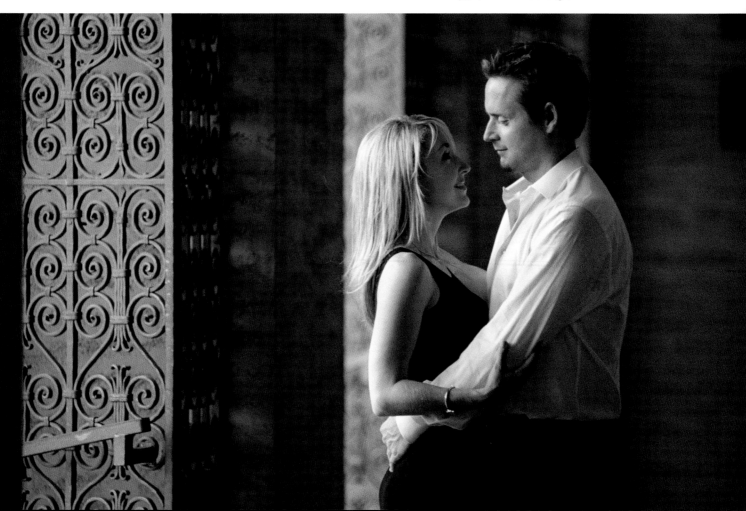

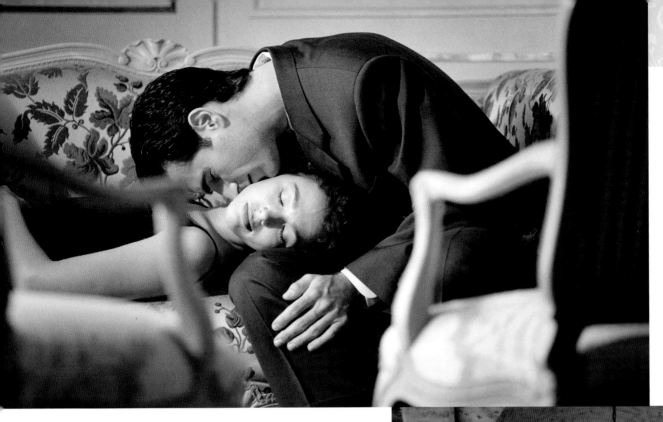

Above: I repositioned the chairs in the foreground to frame the scene and create an intimate vignette and then asked the couple to relax as they might in a quiet moment when alone. Lowel incandescent hot lights, feathered slightly off the main subjects, create a softer appearance.

Nikon F100, 28–105mm Nikkor lens, Kodak BW400CN film, 100 ASA, 1/125 sec. at ƒ/2.8

Right: This image is a perfect example of how magnificent architecture can enhance a couple's portrait. I used a wide-angle lens and a broad depth of field to emphasize the height of this corridor ceiling, include the gothic chandelier, and capture all these elements in focus. All I had to do was position the couple in the center and press the shutter.

Nikon F100, 28–105mm Nikkor lens, Kodak BW400CN film, 100 ASA, 1/500 sec. at ƒ/5.6, natural ambient light

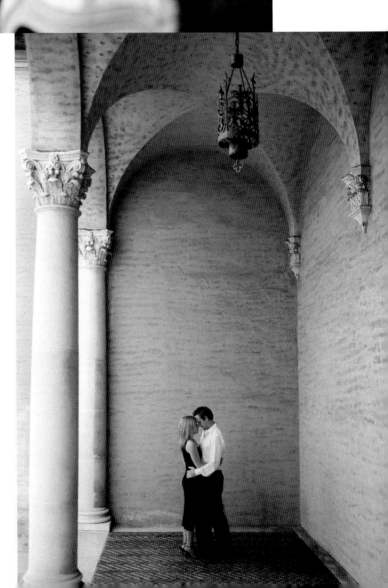

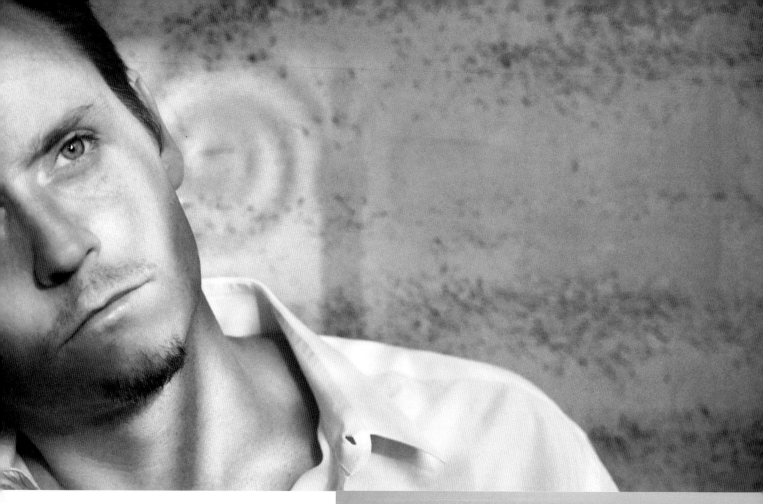

Above: I used shadows to shoot this individual portrait. I was able to position the man's eyes directly into the light looking off-camera. I cropped his face and shot him at an angle to enhance the very soulful and intimate feel.

Nikon F100, 28–105mm Nikkor lens, Kodak BW400CN film, 100 ASA, 1/60 sec. at ƒ/5.6, Tiffen #25 red filter, Nikon soft filter #1, natural ambient light

Opposite: The light cement pillars and brick walls around the cathedral provided natural bounce fill light for this solo portrait. No additional reflectors or flash were needed. The subject's simple white shirt and black slacks offered the perfect contrast for a black-and-white image.

Nikon F100, 105mm Nikkor lens, Kodak BW400CN film, 100 ASA, 1/250 sec. at ƒ/2.8, natural ambient light

Right: Detail images like this one are a great way to complement classic portraits. You can recycle these images into beautiful fine-art pieces or décor art.

Nikon F100, 28–105mm Nikkor lens, Kodak BW400CN film, 100 ASA, 1/125 sec. at ƒ/5.6, natural ambient light

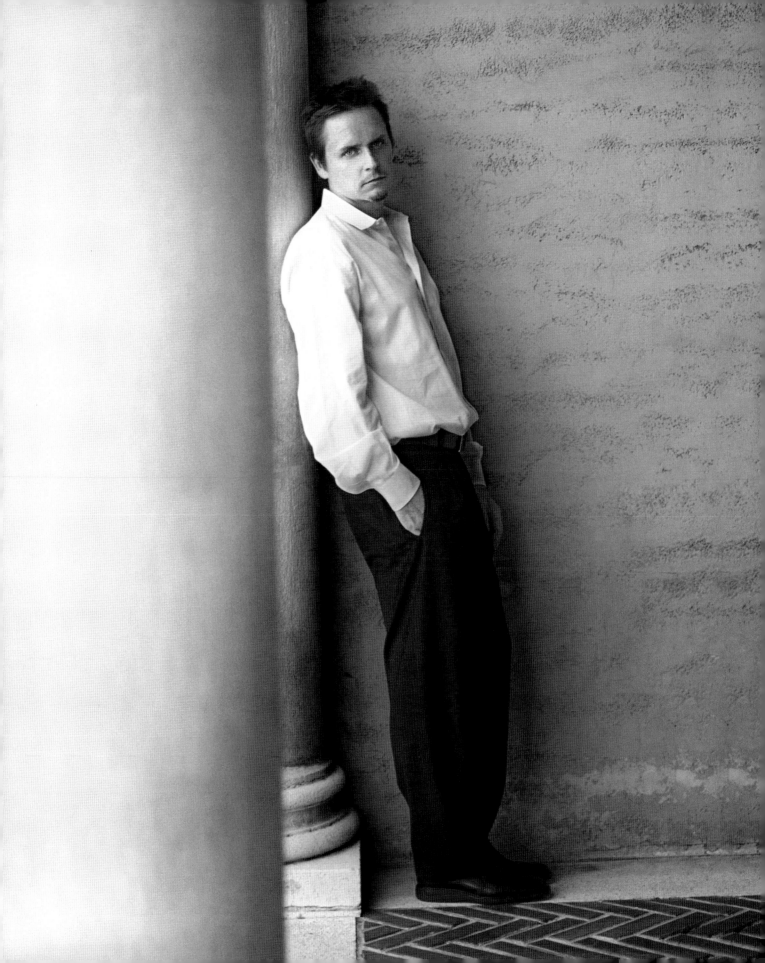

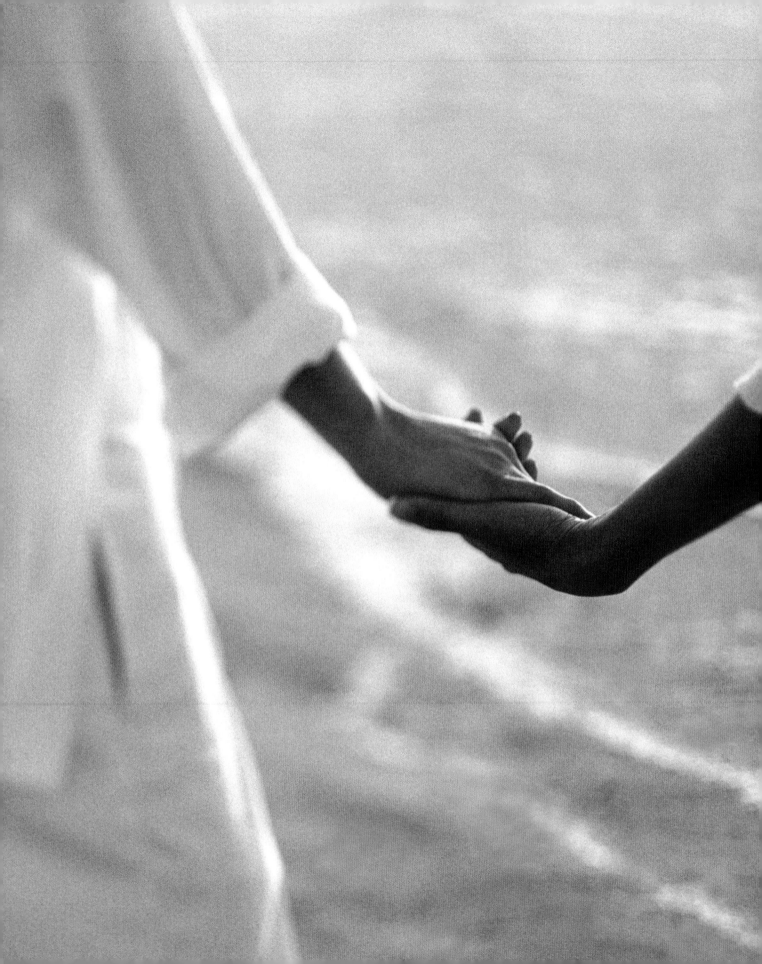

SHOOTING THE ENGAGEMENT SESSION

The engagement shoot is your time to lead, and your personality and passion are the greatest assets you bring to the session. For the couple, the experience is much more than a photo shoot. This is a romantic adventure that they have chosen to undertake together. They are counting on you for your vision and the energy you bring to the shoot. Once you've shot a few frames of various scenes to confirm your composition and lighting choices, share the excitement with your clients by showing them a few shots. This will instantly set them at ease and get the shoot underway on an upbeat note.

TAKING CARE OF ESSENTIALS

As you work out the theme, location, and storyline of the shoot, you will also develop ideas for hair, makeup, props, and wardrobe (see chapter 3). All these elements come together on the day of the shoot.

Hair and Makeup

Makeup is an important element of a shoot. Lighting, pose, and theme will all affect makeup choices. Photographing someone in the wrong light can show every makeup flaw. Strong makeup can enhance a person's best features, especially when using flat, overexposed lighting. More contrasting lighting situations require less makeup because the lighting will bring out creases and wrinkles created by makeup. Hairstyle also helps create a successful image that corresponds convincingly to the theme.

Props

Combining the appropriate props with the right clothing, lighting, environment, and composition can create a dynamic, convincing image. Props can be a lot of fun and can really make an image. They can add style and a chic tone, and they give the couple a chance to play and interact. Props should be suitable to the theme and look natural and uncontrived, and your subjects must be comfortable with the props you choose.

Opposite: A surfboard was the perfect prop to get this couple smiling and having fun, and the yellow and red stripes provided some color to the scene on an overcast day.

Nikon D3, 105mm Nikkor lens, ISO 400, 1/250 sec. at f/4.5, natural ambient light

Below: The hair and makeup for this image were perfect and certainly set the tone. I wanted something very retro but with a high-society, conservative flare. The soft pink lipstick and cheek blush draw the focus to this woman's bedroom eyes and the burgundy feather coat. Fake eyelashes were very popular in the period, and a soft wave lends a classic movie star appearance.

Nikon D3, 85mm PC Nikkor lens, ISO 250, 1/250 sec. at f/3.0, Lowel incandescent lights

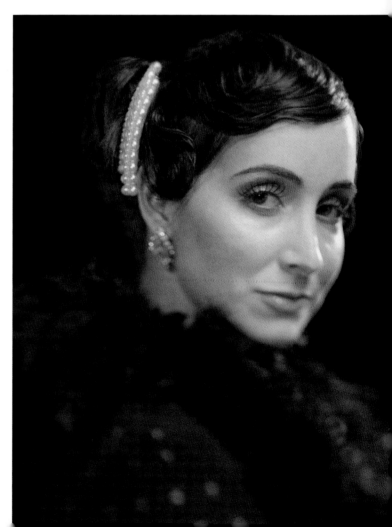

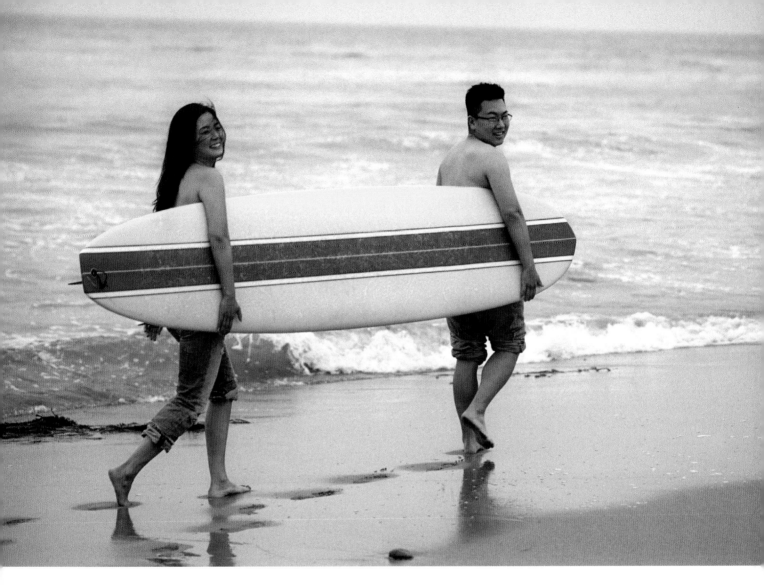

Wardrobe

The right clothing is critical to the success of a shoot, and therefore the wrong clothes can destroy an otherwise great shoot. With the exception of vintage or period-themed photo shoots, classic, timeless clothing works best. Trendy clothes can date a photo quickly. It's also important to consider a subject's personality and body type. Bright, colorful prints do not work well on heavy people, and while black clothing can be slimming and white clothing angelic and romantic, it is important to pay close attention to the contrast ratio and exposure level so you don't lose any details in the black-and-white areas.

Food and Beverages

Having cold drinks and snacks are the key to keeping clients relaxed and feeling a bit pampered. Catering to them can make them feel like stars, and it adds some excitement and entertainment to the shoot session. Because they are not expecting to be fed, they will be all the more impressed.

Ask clients what they prefer to drink and carry a small cooler of cold water bottles, sodas, or alcoholic beverages. A little wine can help make someone who is nervous or camera shy relax a bit. Also bring along some snacks, like fruit, nuts, protein bars, or a baguette with cheese, and if it's cool, a thermos of hot coffee or

tea. Time permitting, take a brief break for a small picnic. I believe good food fuels the soul, and providing these treats to clients helps make my company stand out above the competition.

Directing Your Subjects

You are the director. It is your job to convey to your models what you want and to make them feel completely comfortable. The more experience you have, the more natural this will feel. Once you have a specific image in mind guiding your models into the poses will come effortlessly. It comes down to vision an taking charge and shooting what you think is right.

Involving subjects in the technical process is another way to engage them in the shoot. You might say something like, "This gold reflector is amazing. It creates warm skin tones and illuminates your eyes. . . . You look great!"

You will need to guide (or direct) the couple into what I call a "starting" pose. From this pose they will begin to interact naturally and you can gracefully cue them to other positions. Many of my starting poses coincide with a lighting style. For example, if I see the possibility of a silhouette I might ask the couple to face one another, embrace, put their foreheads together, and close their eyes. I might then ask them to pull their heads back and look at one another for a moment, then ask them to kiss as I grab another shot. From here I'll come behind her and shoot a close up of him looking at her, and then go behind him and shoot with her looking into his eyes. Lastly, I might expand on this theme by asking him to caress the side of her face. I always try to snap a few vertical and horizontal images, as well as close-ups and images shot from farther away. From only one or two shooting positions I can get several different images. I just keep my eyes open and keep shooting variations of poses.

Another consideration when guiding the couple into position is the theme of the session. If you are

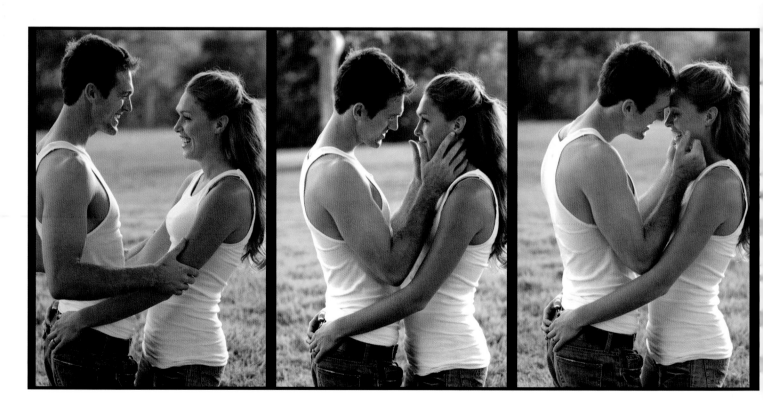

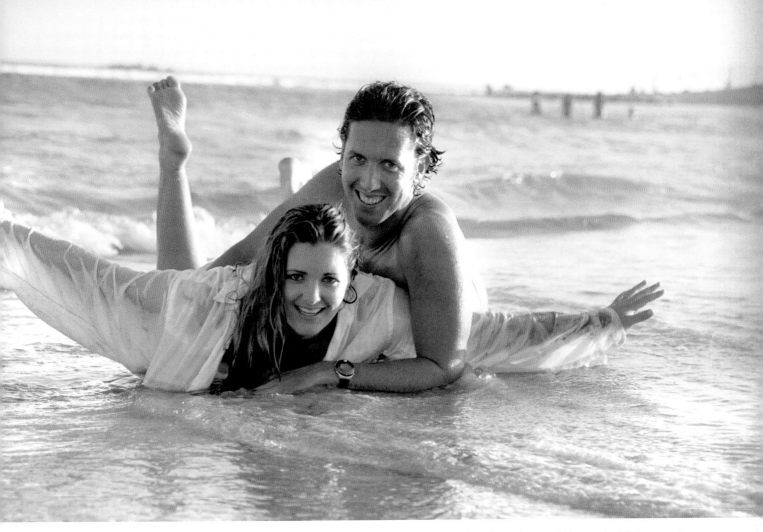

recreating a scene from a vintage Hollywood film the couple might need to be a bit more animated than they normally would. I might show couples some poses from old film stills for a facial-expression reference.

I also take the location into consideration. Surroundings often set the tone. For example, the beach in the summer can be both fun and romantic. I might coach a couple into a playful romp in the surf (this always make them squirm and giggle as the water splashes up on them and provides fantastic candids), or a romantic, relaxed embrace as they watch the sun setting over the water.

Why not have fun in the water? This couple did! They were in heaven playing and laughing in the warm surf. Images like these are a refreshing respite from sentimental, moody, romantic images. I usually save them for last so we can end the shoot with a few good laughs.

Nikon F100, 28–105mm Nikkor lens, Kodak BW400CN film, 100 ASA, 1/250 sec. at *f*/5.6, natural ambient light and white fill reflector

Opposite: Shooting couples in matching attire gives variety to the session. His-and-hers white tank tops with jeans or khakis tend to photograph extremely well. Combining neutral/natural colors with simple/basic clothing allows for the focus to be on the couple instead of their clothing. This is a perfect example of a beautiful, spontaneous moment. I simply asked the couple to stand and look at one another and recall the first time they knew they were in love. They grinned, and this amazing sequence of images happened! It was just what I was hoping for!

Nikon D3, 105mm Nikkor lens, ISO 200, 1/160 sec. at *f*/2.8, natural ambient light

CAPTURING AUTHENTIC, SPONTANEOUS MOMENTS

While your shot list (see page 42) and image reference binder (see page 40) will be your primary guides, your images should look uncontrived, authentic, and spontaneous. If the couple is coming across as too stiff in coached positions, crack a joke to make them laugh. Or pause and pretend to fiddle with your gear (as if you're changing film, digital cards, or lenses, all the while watching them out of the corner of your eye). In moments like these, they tend to relax and fall into a more natural position with one another. This is the perfect time to click the shutter.

It comes down to the couple's natural chemistry. Some couples feel embarrassed about expressing public displays of affection, while others are lost in the intoxication of their love and passion. It is important to tune in to how they are feeling and respect the comfort zone of each individual couple.

Below: There's nothing like a hammock to provide a relaxed moment and bring out a couple's genuine affection for one another. Even without the aid of a prop like a hammock, with a little artful direction you can probably capture many authentic moments like this.

Nikon F100, 28–105mm Nikkor lens, Kodak BW 400CN film, 100 ASA, 1/125 sec. at f/5.6, natural ambient light

Opposite: This couple was shy at first but obviously very much in love. By asking them to gently rest their faces together and close their eyes, I was able to capture the intimate image I was hoping for.

Nikon F100, 105mm Nikkor lens, Kodak BW400CN film, 100 ASA, 1/125 sec. at f/2.8, natural ambient light

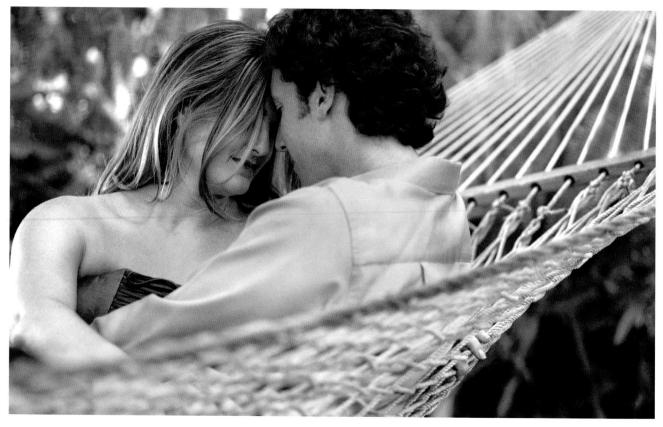

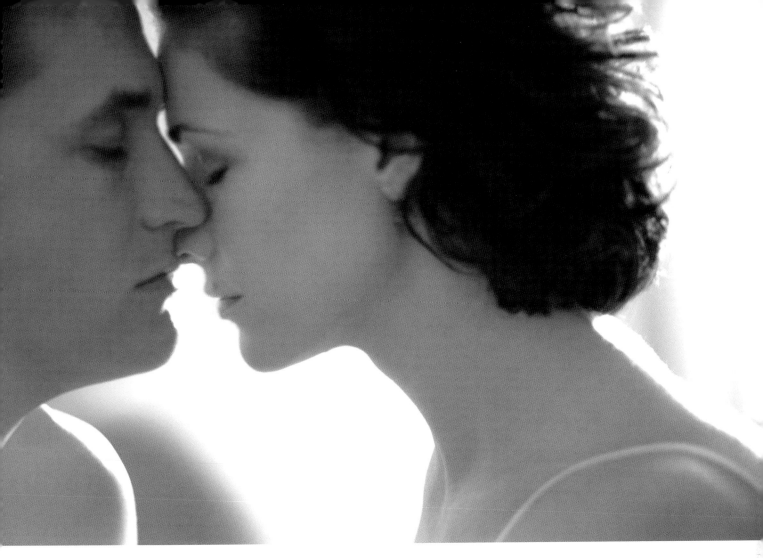

CAPTURING INTIMATE MOMENTS

Close-ups require attention to details. Most important, just relax, take a deep breath before clicking the shutter, and allow the person to "be."

- If a person has fine lines and/or blemishes, adjusting the lighting or the posing ever so slightly can produce much better results. I almost always place the main light behind them (known as backlighting; see page 88) and use flattering, more evenly toned lighting for the faces. If this still isn't enough, I may over expose by ½ to ⅔ stop to blow out the finer facial details.

- Shoot slightly out of focus to create a softer, moodier effect.

- Shooting with a very shallow depth of field (also referred to as "shooting wide open"), such as with an aperture of $f/2.8$ can create an intimate feeling, while shifting the focus away from any problem skin areas.

- Zoom in for some detailed body shots. Hands and feet are sensuous and very expressive parts of a person.

CAPTURING LOCATION DETAILS

When shooting an engagement session, try to view the production as a director might when shooting a film scene. Look for clues, still lifes of different objects, scenic vistas, and other artifacts that support a theme and establish the storyline. It could be a crisp blade of grass, a street sign, animals, or maybe an architectural detail. If you're shooting an elegant architectural theme, the images might be a close-up detail of a woodcarving, an elegant chair, a door hinge, or an antique mirror. These images will balance out the people images—giving the viewer a refreshing pause. You do not need to take these images during the actual shoot for which you'll be using them. You can take them while location scouting or while on a different assignment.

Your objective is to have a library of images you can later use when creating image combinations or page layouts for an engagement book, other portfolios, or your website. The still-life images make the page layouts so much more interesting, because they give the viewer a refreshing break from images of people. Get creative and have fun! Play with various images, tones, shapes, colors, and themes. Let your camera wander, and see where it leads you.

Opposite, top: Although I took this image during a Paris vacation, I was able to use it in conjunction with a French-themed shoot that I later shot in an old town in California. I am always looking for great detail shots to pair with images of couples to support themes and create variety in a layout.

Nikon D3, 85mm PC Nikkor lens, ISO 100, 1/160 sec. at f/4.8

Opposite, bottom: The texture and detail added a lot to the group of images presented to the client. I also incorporated this shot into a double-image spread for my website.

Nikon F100, 28–105mm Nikkor lens, Kodak BW400CN film, 1/250 sec. at f/4.5, natural ambient light

Below: The morning dew in this pasture made for a perfect detail shot for a country theme shoot. Still lifes of nature are refreshing when paired with images of people and help support the session's theme.

Nikon D3, 105mm Nikkor lens, ISO 320, 1/250 sec. at f/2.8, natural ambient light

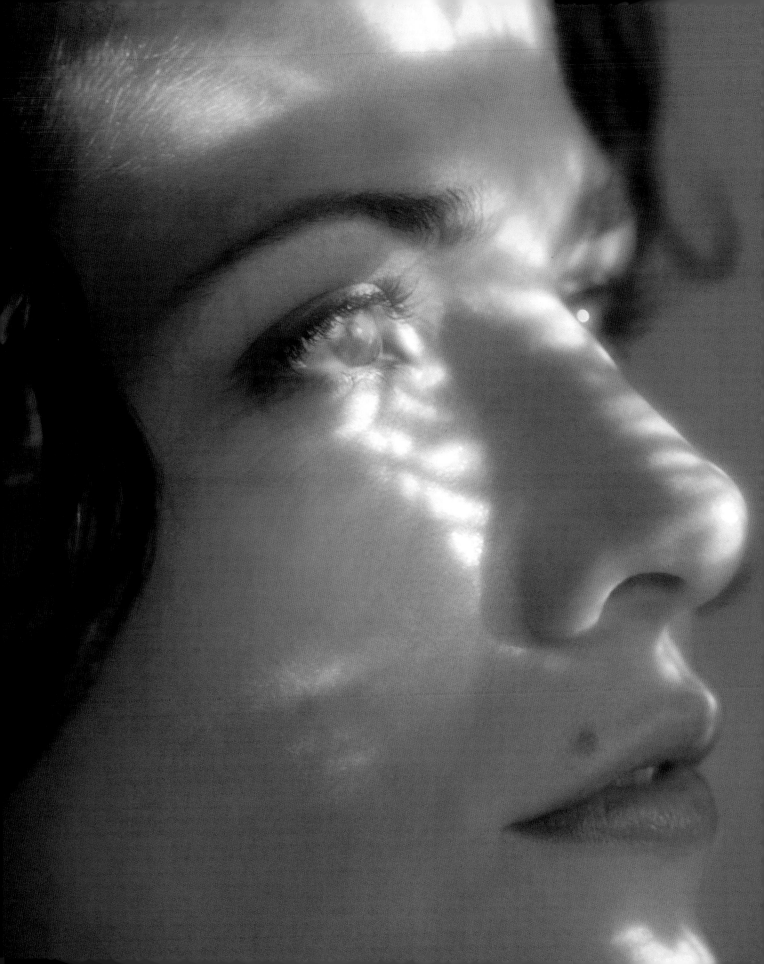

Chapter 6

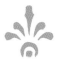

LIGHTING

Lighting is the photographer's voice and is essential to defining the emotion of an image. You don't want to shout in the viewer's face; you want to whisper, to seduce by creating subtle nuances, and you can do so by lighting selectively, sparingly, and, most of all, thoughtfully. A high-key image has brighter and lighter tonal values, while a low-key image has darker, moodier tonal values. The right lighting can create either, and whether you manufacturer lighting artificially or discover just the right light in a natural setting, you should be able to create the lighting for the look and feel you wish to convey.

DIFFUSED, FLAT LIGHT

In diffused lighting, the light source is not discernible, creating a soft, romantic effect. Shadows are not present with diffused lighting, greatly diminishing lines, wrinkles, and dark circles under the eyes. Little wonder this style of lighting is often called "glamour lighting" and is a favorite with fashion photographers for head-shots. In a studio, two lights (either flash strobes or tungsten hot lights) are usually placed on either side of the camera facing the subject and the light is diffused with large soft boxes or a diffusion screen or bounced backward off a white wall or umbrella head. When shooting outdoors, you'll come upon diffused natural lighting at sunrise, sunset, and on an overcast day.

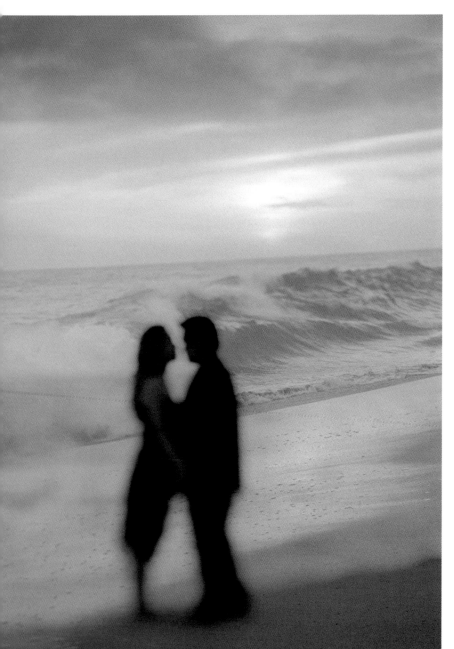

Left: In this image, captured seconds before the sun set behind the horizon, the focus shifts from the couple to the magnificent waves behind them. The combination of the soft blue light and shifted focus produces a creative, moody image.

Nikon D700, 85mm PC Nikkor lens, 1/15th sec. at ƒ/2.8, ISO 800, tripod, natural ambient light

Opposite, top: Bright afternoon split lighting can be a perfect way to enhance shapes, such as the curves of this subject's hat and dress.

Nikon F100, 80-200mm Nikkor lens, Kodak BW400CN film, 100 ASA, 1/500 sec. at ƒ/2.8, natural ambient light

Opposite, bottom: Splitting this subject's face and body with light works really well to enhance a composition.

Nikon F100, 80-200mm Nikkor lens, Kodak BW400CN film, 100 ASA, 1/500 sec. at ƒ/2.8, natural ambient light

SIDE LIGHTING

This very dramatic lighting pattern, also known as split lighting, employs strong, directional lighting coming at a 90-degree angle to the subject. The angle splits the lighting down the center of the subject—illuminating one side of the face and creating a shadow on the other.

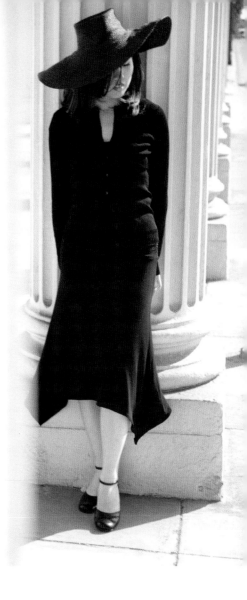

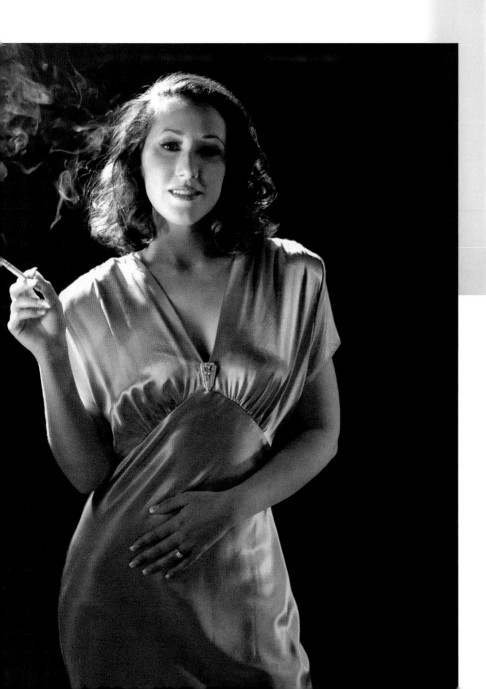

REMBRANDT LIGHTING

Rembrandt, the seventeenth-century Dutch painter, was known for using a specific form of lighting in his portraits. He placed the main light at a 45-degree angle to the subject's face to illuminate one side and create a small triangle of light on the other cheek. This is a very useful technique for slenderizing a full face or to give a portrait a classic, traditional look.

DAPPLED AND PATTERNED LIGHTING

You'll often come upon this dramatic lighting pattern outdoors, where shadows from a tree branch, gate, or other patterned objects fall against a wall or subject. You can create this light in a studio by placing a patterned object or grid in front of a strong directional light. When applied correctly, this lighting can create beautiful imagery.

Opposite, top: The shadows come from an ornate iron gate in late afternoon light. With some careful positioning, they create an interesting pattern on my subject.

Nikon F100, 28–105mm Nikkor lens, Kodak BW400CN film, 100 ASA, 1/30 sec. at f/4.5, tripod, natural ambient light

Opposite, bottom: Here's an example of finding the best lighting in your surroundings and going with it. Just when I decided that the sunlight was too bright to shoot anything we had on our shot list, I turned around and discovered these amazing shadows from the leaves of a maple tree flooding the wall in front of us! I simply positioned the couple in an opening of light and had them look off-camera.

Nikon F100, 28–105mm Nikkor lens, Kodak BW400CN film, 100 ASA, Tiffen 1/125 sec. at f/4.5, #25 red filter, Nikon soft #1 filter, natural ambient light

Below: This is an excellent example of Rembrandt lighting. This guy had movie star good looks, and his calm demeanor encouraged me to zoom in and see who he really was! I removed him from the direct sunlight to the edge of a shaded area and then used a white reflector at just the right angle to bounce light into his eyes, while maintaining the deep shadow that gives definition to his chiseled features.

Nikon F100, 105mm Nikkor lens, Kodak BW400CN film, 100 ASA, 1/60 sec. at f/2.8, natural ambient light with white fill reflector

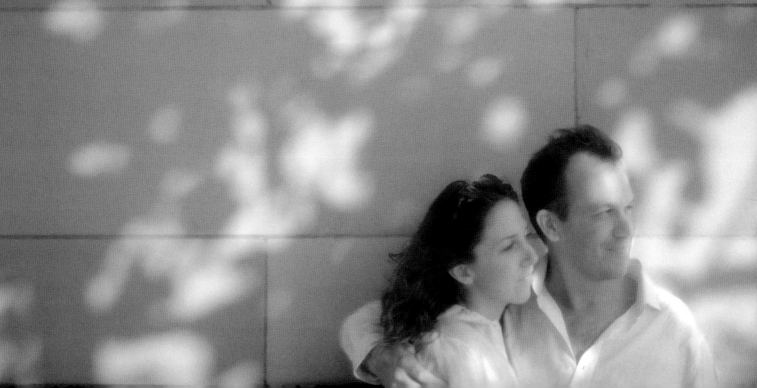

BACKLIGHTING

In backlighting, the main light source is placed behind the subject. Especially in bright sunlight, the effect can be sensuous and romantic, great for solo portraits and nature images. It creates a natural white rim light behind the head or body, outlining and separating the subject from the background. When using backlighting outdoors, position yourself in the shade or use a lens hood so you can keep direct sun from going into your lens and causing lens flare (unless you are intentionally trying to achieve a misty, moody, hazy effect. You can add some front fill light with a reflector or diffused flash.

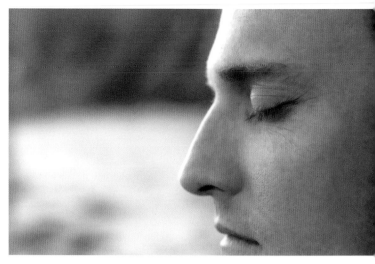

Above: Notice the white rim of light outlining this man's profile. This is another example of the beauty of backlighting. I simply suggested he close his eyes and take a deep breath of fresh air.

Nikon F100, 105mm Nikkor lens, Kodak BW400CN film, 100 ASA, 1/125 sec. at f/2.8, natural ambient light

Below: Backlighting was ideal here because of the way it outlines the swing and feet. I positioned my models with the afternoon sunlight behind them and stood in the shade of the tree to protect against lens flare.

Nikon F100, 28–105mm Nikkor lens, Kodak 160NC film, 100 ASA, 1/500 sec. at f/5.6, 81A warming filter, natural ambient light

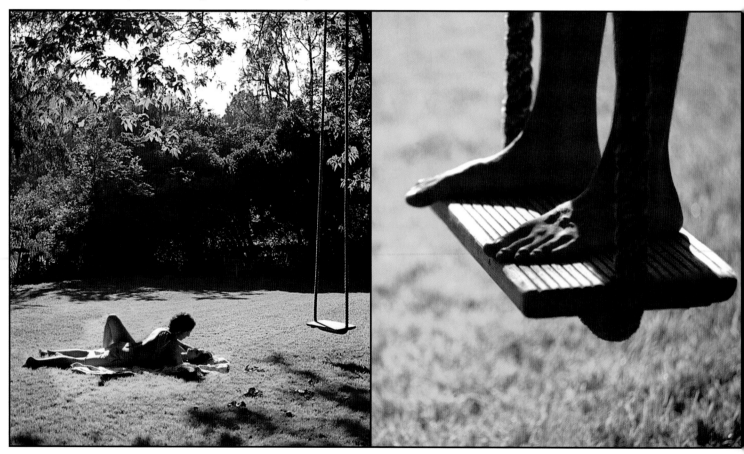

SILHOUETTE LIGHTING

A silhouette is a high-contrast image where the main subject is very dark and the background is very bright. Silouettes are usually low-key images, with dark, moody tonal values and a dramatic lighting ratio difference between the foreground and background of the scene. For the best results, set your camera's exposure meter on the matrix (or broad) setting. This will measure the light of the entire scene. It's best to expose for a slightly darker image so your shadow areas become deep and rich. To achieve this, you can underexpose by a half to a full stop, depending on the effect you want. It's important not to use the spot or center-weighted settings on your meter or your subjects will become too illuminated and you will lose the silhouette effect.

Above: This is an example of a silhouette image. To create this, I positioned the couple on the dark, shaded front porch of their home with bright afternoon light behind them. I underexposed the entire image one full stop, and it worked perfectly.

Nikon F100, 70mm Nikkor lens, Kodak BW400CN film, 100 ASA, 1/250 sec. at f/2.8, natural ambient light

Right: This is another example of a silhouette image, shot as the sun was setting over the ocean. The camera exposed for the brightly lit sky, forcing the couple to fall into the deep shadows. It can be tricky to create images like this. You need to wait for the right moment to get the right light, but it will be well worth it.

Nikon F100, 20mm Nikkor lens, Kodak BW400CN film, 100 ASA, 1/250 sec. at f/2.8, natural ambient light

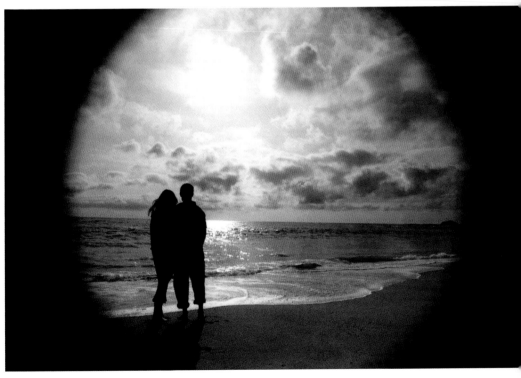

SHADOW LIGHTING

You can create shadow images by placing the main subjects in front of a very bright light source in a dimly lit environment. You then shoot the shadow that projects itself onto an adjacent, lighter-toned wall. This can create some very romantic imagery. The vaster the contrast ratio between the highlights and low lights is, the stronger the shadow will be.

Above: Bright sunlight works the best to create the strongest shadows. Using a wide-angle Nikkor lens, I positioned the couple just out of frame in front of a heavily leafed tree and shot their shadows kissing. To create the black vignette around the edges of the frame, I used a large black Nikkor lens hood.

Nikon F100, 28mm Nikkor lens, Kodak BW400CN film, 100 ASA, 1/500 sec. at f/4.5, natural ambient light

Left: This is a perfect example of the use of shadows. To create this low-key, moody image, I positioned the nuzzling couple in front of a large picture window with magnificent ornate details and simply shot their shadows projected against the wall.

Nikon F100, 28–105mm Nikkor lens, Kodak BW400CN film, 100 ASA, 1/125 sec. at f/4.5, Nikon soft filter #1, Tiffen #25 red filter, natural ambient light

Opposite: A few clouds needn't get in the way of an engagement shoot. The diffused light of an overcast day is soft and romantic and can help create extremely evocative images that are ideal for engagement images.

Nikon F100, 85mm PC Nikkor lens, Kodak BW400CN film, 100 ASA, 1/60 sec. at f/2.8, natural ambient light

MAKE THE MOST OF THE LIGHT YOU HAVE

You don't need fancy lighting gear to create incredible images. The best light, natural light, is all around you. A simple reflector disc or diffused flash can add some needed fill light, but sometimes even this gear is not required.

Put the camera to your eye to explore and experiment. Look at the direction the light is coming from and how you might position your subject around it. The subtlest shifts of the light in reference to the subject you're photographing can affect the emotional quality of your image. For this reason it is extremely important to know the exact emotion you want to convey. Whether you want the mood to be dramatic, playful, romantic, or sensuous, you'll probably be able to create the right feeling by using available light.

Light is constantly changing positions at different times of day and year. For this reason, it is best to location scout as close to the shoot date as possible to achieve duplicate lighting conditions. When you find a light/pose combination that expresses your voice, take a quick snapshot and record it. However, keep in mind that weather conditions can fluctuate at any given time. You may scout locations during a sunny day and come up with ideas for shooting with contrasting light, then wake up to an overcast sky on the day of the shoot. Do you postpone? Absolutely not! Revert to a trusty plan B for diffused lighting conditions. Incredible images can be made in any kind of lighting and I relish the challenges of making them work.

AN ENGAGEMENT SESSION . . .

in the Studio

Although I prefer photographing on location in natural settings, shooting inside in a controlled environment can be equally rewarding. One big plus: Stormy weather, onlookers, parked cars, and snakes are not a concern when shooting inside, and you also have the comfort of creating your own lighting and setting a scene in your own time frame. But additional props, artificial lighting, and location or studio rental fees may apply, and if you're shooting in an empty studio, you may need to fabricate an entire scene with backdrops and many props. Plus, if the studio doesn't have the natural window lighting you desire, you will have to create it artificially.

Lighting in Studio

You have a choice between hot lights, small flashes, and larger strobe flashes. I use all three options in different scenarios. Each device will give you a different kind of light and a different look. You will want to explore the options and determine which works best for which shoot situations.

My Nikon Speedlight System is great when I need extra light on location. Each lightweight flash head is wireless and powered by AA batteries. Power for each flash can be controlled individually. When I'm shooting in an interior location, I use my Lowel incandescent hot lights. They render a slightly different kind of light that's hotter and warmer and provides a bit more contrast and a lot more warmth. The quality of the light is cinematic (matching my style of photography), similar to the effect of big lights you find on movie sets. Yet to achieve it you do not need a bunch of giant, cumbersome, space-consuming light boxes and heavy, expensive strobe power packs. The light kit I have contains four light heads (two square Tota lights

Looking at old pictures, I've noticed that a lot of images were out of focus or the focus point was any place but the subject. Expressions were often very aloof and sometimes mysterious, and before the invention of color film, many black-and-white images were hand tinted. I wanted to incorporate all of these elements into this image, so I intentionally tilted the woman's hat over one eye and gave her a blank expression. I used color film and later desaturated the color in Photoshop.

Nikon F100, 85mm PC Nikkor lens, Kodak 400 NC film, 200 ASA, 1/60 sec. at f/2.8, Lowel incandescent hot lights

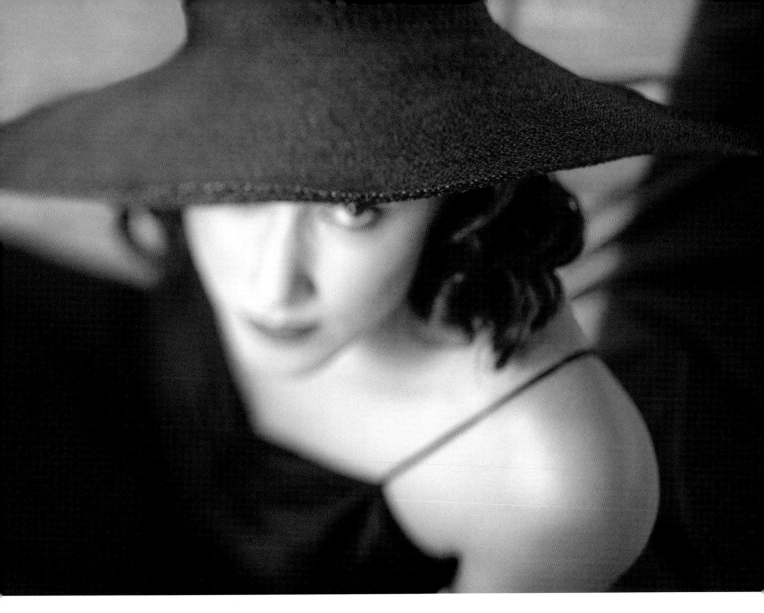

and two rectangular Omni lights), diffusion holders, a diffusion screen, snoots, and plugs. The Omni lights use 500-watt or 700-watt bulbs, and the Tota lights are fixed 500-watt bulbs.

There are pros and cons to hot lights. They fit neatly into a compact, lightweight bag the size of a small suitcase. I can see the look and quality of the light on the spot with my naked eye, eliminating the need to shoot several tests and play with the control settings. This being said, the lights get very hot, and you will need gloves to move them into place. The lights are also not as powerful as strobes, and unlike strobes and flashes, which can operate on wireless re-mote from a main battery power pack, each hot light requires its own power plug.

The terms *main light* and *fill light* are common-ly used in studio lighting. The main light is usually the strongest, most-contrasting light source. I usually place this light behind a subject to provide a strong rim light for hair or body and blow out any details I don't want in the background. The fill light is usually the softer, more diffused light. This light literally "fills" in shadow areas. It's usually a flat, consistent kind of light. You can also fill shadow areas by bouncing in a fill card or reflector disc. I always bring one along with my light kits because it adds another dimension to the light and doesn't require batteries or plugs. For more on lighting, see chapter 6.

THEME:
THE GREAT GATSBY

This vintage theme shot was inspired by the film *The Great Gatsby*, starring Robert Redford and Mia Farrow about high society in the roaring 1920s.

LOCATION: I researched a number of locations before I found a deserted warehouse (cobwebs, rotten wood, and all!). I tested all the power outlets and was delighted they still worked. I gained permission from the property owner and began prepping the location for my clients. This involved a bit of cleaning (removing animal droppings, insects, and even a dead rat my assistant was kind enough to dispose of!). I wanted to make sure the couple would feel comfortable in this environment.

WARDROBE: We rented a variety of vintage clothing items so we could play with looks and styles in each setting. We found two gorgeous dresses, including a peach satin gown to match the woman's pearl-colored, satin gloves. We then selected two suits—one double-breasted suit and the other a tuxedo with a bowtie. The best part was finding retro hats for my subjects. "Stunning" was all I could say!

HAIR AND MAKEUP: We wanted a hairstyle for the bride that would definitely be evocative of this period. We poured through vintage images for the right hairstyle and then found it. We chose a soft, deep-peach-colored lipstick to complement the peach dress and light grayish eye shadow tones to match the man's deep-gray suit and the gray shadow areas of the scene. Our hair and makeup artist did her magic, and we were ready to shoot.

PROPS: I brought a stack of old books and magazines, including the *Look* magazine from 1948 she's holding in the image at right.

DIRECTING: I shot the broader images first and then zoomed in for the intimate close-ups. This seems to be a natural progression in any relationship. I asked them just to look at one another and then close their eyes; they just melted together and were like putty in my hands.

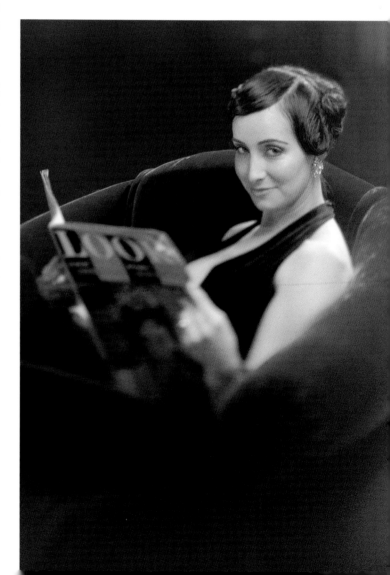

Left: This high-key image was created with a combination of three different light sources: natural existing light, artificial incandescent hot lights, and flash. Natural light was coming from skylights above and an open window behind, but I could still see details in the background. I used two 700-watt Omni lights to blast light into the background and then used my flash to illuminate the details on my subjects' faces and clothing. I overexposed the entire scene one full stop to make them glow.

Nikon D3, 85mm PC Nikkor lens, ISO 400, 1/60 sec. at ƒ/2.8, natural ambient light and Lowel incandescent hot lights, Nikon SB900 flash with Apollo light modifier as diffusion

Opposite: This image was created using all natural lighting. We were fortunate to have a skylight in this building, so we positioned a burgundy velvet chair beneath it for a natural diffused light. The white pages of the magazine the woman was holding bounced a beautiful fill light into her face.

Nikon D700, 85mm PC Nikkor lens, ISO 320, 1/60 sec. at ƒ/2.8, natural ambient lighting

THEME:
GAS, FOOD & LODGING

The main inspiration for the theme of this session was an old car I found in my friend's garage. When I saw it, I instantly envisioned the images I could make. I expressed my ideas to a couple and they loved them, and my friend agreed to lend us the car. My objective was to tell a story about the thrill of travel in the 1940s and 1950s, when America was building highways across the nation and advertisements depicted happy American couples driving down a road with road signs in the background that said "Gas, Food & Lodging."

While the image below could have been shot outside, shooting it in a studio enabled me to have more overall control. My trademark lighting style gave this image a more cinematic, advertising-quality look. I wanted the man to be the primary focus on this image, so I was careful to set my aperture at *f*/5.6 (instead of my normal *f*/2.8 setting for portraits) to make sure she wasn't completely out of focus. See page 24 for other images from this session.

LOCATION: When I scouted the warehouse location, I found a garage in the back that had a fair amount of natural light. I knew that with the help of my flashes and hot lights it would work perfectly. We played with the positioning of the car until we found the perfect spot, then my assistants placed a clean blanket on the old seats to protect the models' clothing and make the subject's feel more comfortable.

WARDROBE: The vintage hats really made this shot. She wore a simple V-necked dress and he wore a double-breasted suit and tie. That's all we needed. Their expressions were just perfect!

Opposite: For this car shot we combined existing natural ambient light with several different hot lights, each highlighting different areas of the scene. One light head was used with a snoot for each subject's face. A snoot is a long tubelike funnel that narrows into a spotlight. Two additional lights were placed behind the car to blow out details in the background. This created a thin rim light behind the man's jacket, separating it from the dark backseat.

Nikon D700, 105mm Nikkor lens, ISO 320, 1/60 sec. at *f*/5.6, natural ambient light and Lowel incandescent hot lights

Below: For this man's portrait, we used two hot lights: One Omni light was placed inside the closet adjacent to him to highlight the rim of his hat and the cobweb next to him, and the other was diffused, snooted, and spot-focused to front-light him and the wall next to him.

Nikon D700, 85mm Nikkor lens, ISO 320, 1/60 sec. at *f*/2.8, natural ambient light and Lowel incandescent hot lights

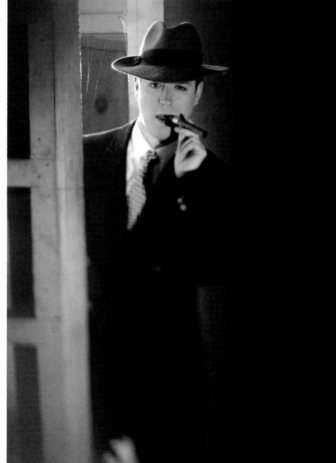

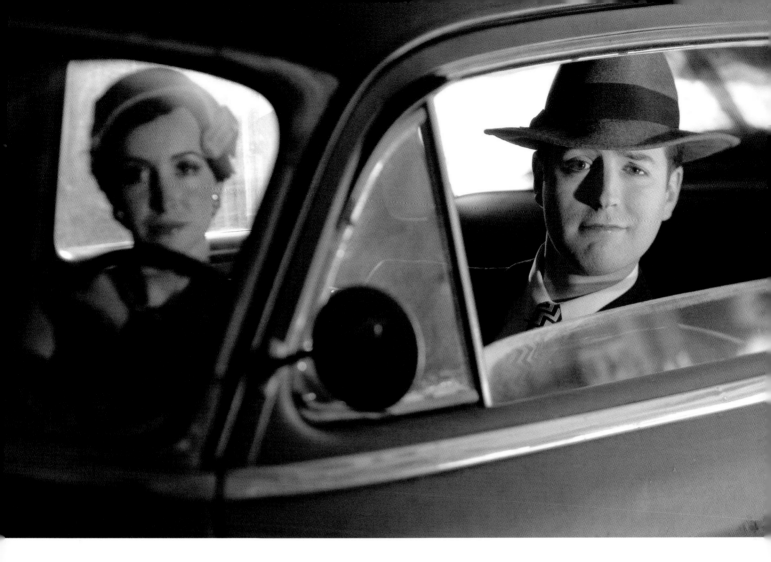

HAIR AND MAKEUP: Our makeup specialist applied a sheer, light lip balm to give the man's lips a slight reflection, as well as a minimal amount of foundation to cover minor blemishes and razor burn. She reassured him that he would not look feminine and would maintain his same masculine features. Many men are resistant to makeup, so it is the job of the photographer and the makeup artist to educate them. I remind men that what we see with the naked eye is very different from what will actually display in the final pictures.

PROPS: The car became the main prop for this setting. We had some items like a map and an old newspaper, but they didn't work well. They competed with the car and the couple, and this created confusion in the image (who reads a map while they're driving?). This is a good example where less is really more.

DIRECTING: We showed the couple some sample images from our idea binder of advertisements from the 1950s and they got it. By this time they were warmed up, and my sarcastic personality helped them get into character. We really had a good time playing with different expressions.

THEME: CASTING CALL FOR A HOLLYWOOD STARLET

When I met this couple I looked at her and immediately saw a vintage movie star—a real Hollywood starlet from the 1930s or 1940s. I knew it wouldn't take much to convince her and get her into character. I saw him playing the part of the dominant movie director. As ideas emerged we began to see the story and called it *Casting Call*. I knew this theme would work perfectly in a studio setting.

Opposite I pinned images from my idea binder to a foam core board for the hair and makeup artists to use as reference. These images educate my entire crew to the look and feel we are aiming for. It really helps!

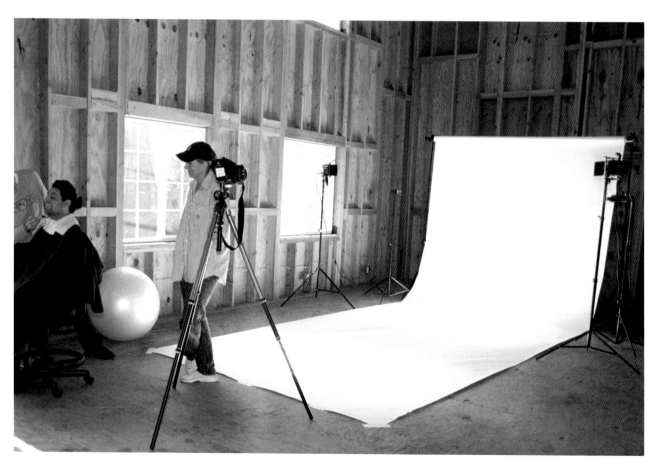

This is our set shot. I brought in a simple white paper backdrop because I wanted the scene to be much like how a generic casting session might have appeared back then. The natural window light on the left side was perfect for some of the shots, but we had to block out the light for others.

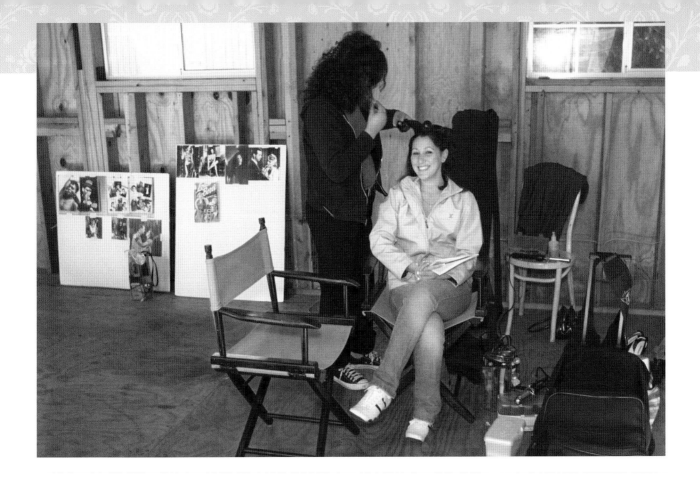

LOCATION: I wanted a very controlled environment that would allow us to adjust the lighting when needed. This small studio was affordable, clean, and large enough for us to shoot with long lenses.

WARDROBE: I flipped over the pin-stripped suit. It was just too loud and yet perfect at the same time. It gave the guy a bit of flashy flare and instantly transformed him into a confident Hollywood director. The woman found two dresses she liked: a classic black cocktail dress from the period and a sexy, satin V-necked scooped dress. We opted for both and she did a simple clothing change in between takes.

HAIR AND MAKEUP: Watching the transformation was a pleasure. I asked for dramatic makeup for the woman because I wanted to see her features from a distance in the long shots.

PROPS: The old Super-8 movie camera, a retro still-film camera, a folding director's chair, and cigarettes for her and a cigar for him were definitely key elements that brought the entire shoot theme together.

DIRECTING: I shared with the couple the story I had in mind: He is the arrogant film director looking for his new Hollywood starlet, and she is the up-and-coming actress who is shy but trying to make her break. He does a test shoot of her, and, of course, she flirts and impresses him. In the end she lands the part and he gets his girl.

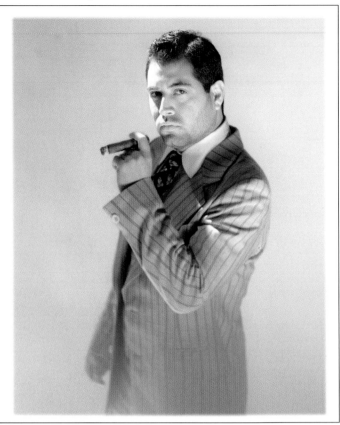

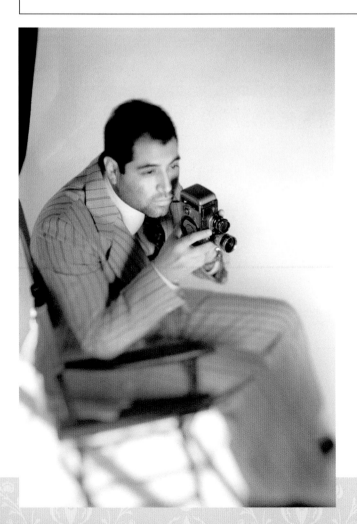

Above: This is one of the double-image spreads I use in my portfolio. This portrait of the man was made by combining existing daylight with artificial and incandescent hot lights. The main key light for his hair and side of his face came from window light, and my hot lights filled in the remaining front of his body. He loved the cigar, and this really helped him get into character. The image of the old Super-8-movie camera was lit with two hot lights—the main light placed behind the camera and the fill light placed to illuminate details of the camera body in the foreground. Pairing these two images together seemed perfect.

Both images: Nikon F100, 85mm PC Nikkor lens, Kodak BW400CN film, 100 ASA, 1/125 sec. at f/2.8, natural ambient light and Lowel incandescent hot lights

Left: This action shot of the man shooting with his camera is a great way to help tell the story. Everyone likes playing the part of someone else for a bit, and it makes clients feel like real stars. We intentionally used diffused lighting on the man to offset the high-contrast images of the woman, the so-called actress during her casting call.

Nikon F100, 85mm PC Nikkor lens, Kodak BW400CN film, 100 ASA, 1/125 sec. at f/2.8, natural ambient light and Lowel incandescent hot lights

Opposite: I intentionally chose to show the edge of the studio backdrop and the tension in the distance between the subjects to establish the "director-meets-actress" moment. The natural daylight flooding into the floor created a unique frame.

Nikon F100, 85mm PC Nikkor lens, Kodak BW400CN film, 100 ASA, 1/125 sec. at f/2.8, natural ambient light and Lowel incandescent hot lights

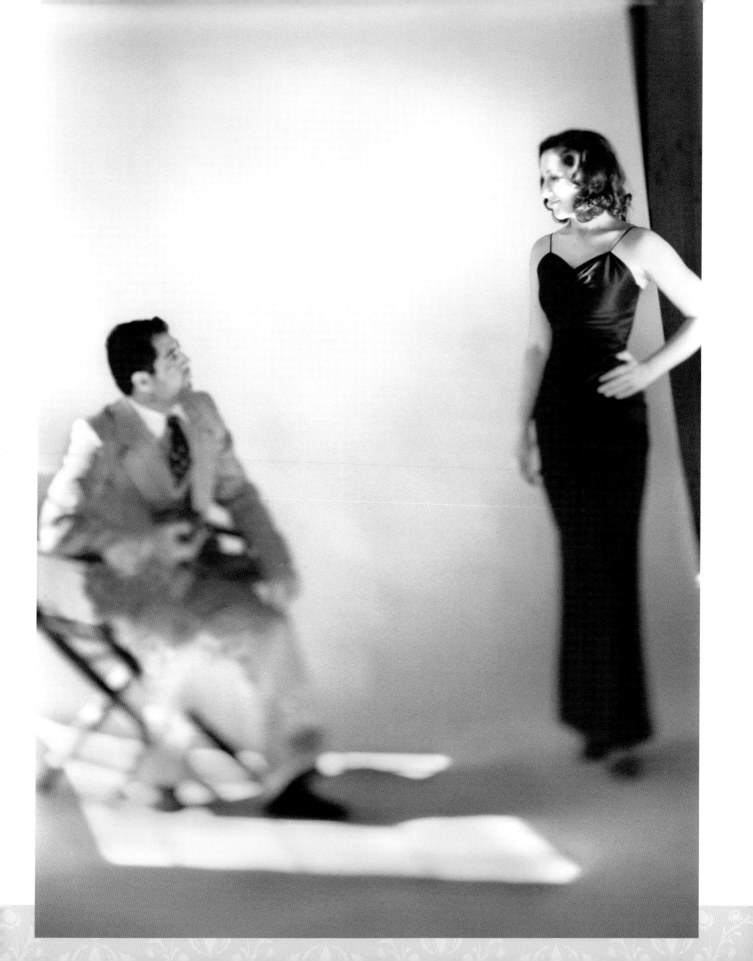

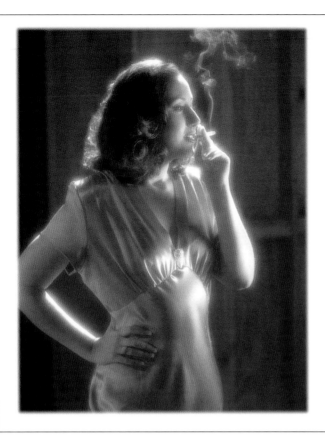

Above: The vintage shoes were so beautiful I just had to take a still-life shot of them on this old French café chair. To capture the lingering cigarette smoke, I used strong backlighting on the subject's head and shoulders, flat fill light to illuminate her satin dress, and a faster shutter speed. The backlighting created drama. These were the keys to making this image successful.

Both images: Nikon F100, 105mm Nikkor lens, Kodak BW400 CN film, 100 ASA, 1/250 sec. at f/2.8, Lowel incandescent hot lights

Opposite: He finally gets the girl! This classic portrait was created using a bright main key light behind the couple to illuminate their heads and the side of his face and one diffused fill light to illuminate their faces.

Nikon F100, 85mm PC Nikkor lens, Kodak BW400CN film, 100 ASA, 1/125 sec. at f/2.8, Lowel incandescent hot lights

Right: I love the woman's expression in this pose. I intentionally directed her to bend at a 45-degree angle when kissing her fiancé's cheek. An over-exaggerated pose like this is common in imagery of the period. A small spotlight placed on the backdrop behind the couple frames the kiss.

Nikon F100, 85mm PC Nikkor lens, Kodak BW400CN film, 100 ASA, 1/125 sec. at f/2.8, Lowel incandescent hot lights

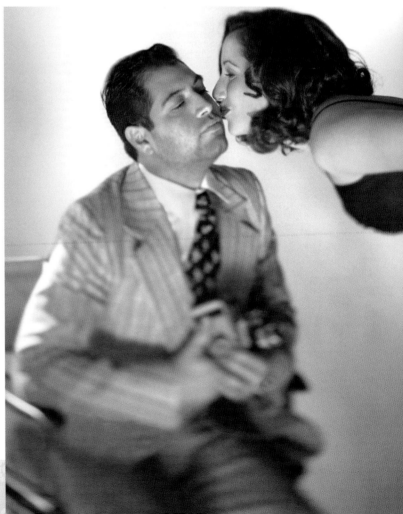

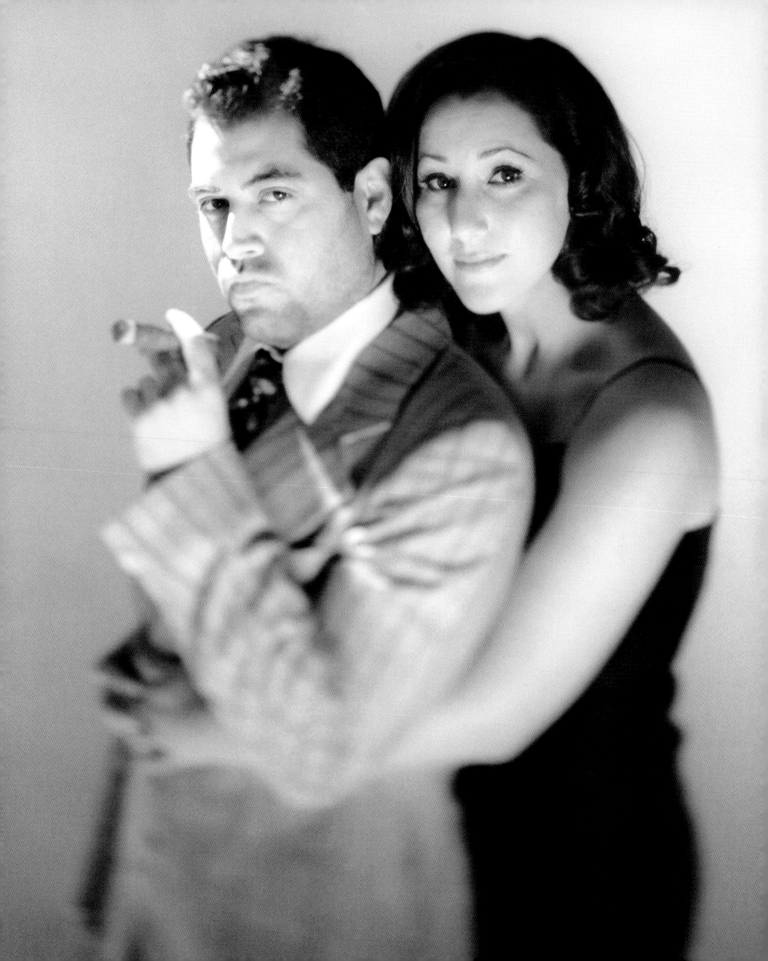

Chapter 7

EDITING AND RETOUCHING YOUR IMAGES

A great image needs no explaining. Yet even a close-to-perfect image might require a little fine-tuning. Analyze each and every frame and of your work, and for each one ask yourself, "Is there anything that could make this image better?" You may have looked at the same image a thousand times and never noticed the one element that can be improved upon with a simple bit of retouching, color adjustment, or skin enhancement. With a little extra care, you can consistently deliver images that are clean, beautiful, and, like your reputation, professional and polished.

SELECTING AND PROCESSING

You might, of course, see images in a digital LCD screen as you shoot, but you may still be surprised at how they actually look on a large computer display screen back in the office. Looking at them on a large screen is the beginning of the selection process, and from the get-go your objective is to give your clients only the very best.

I usually present clients with no more than five to eight final retouched images for each scene setting. These might include horizontal, vertical, color, and black-and-white image variations and a few different expressions. What matters most is to choose the most flattering images of the couple (even if they are not your most "creative" or unique images). People want to like themselves in their pictures, and your goal is to make your clients happy. On a purely practical note, if your clients feel good about the images you create, they are more likely to refer you to their friends.

Although I have a very strong sense of the images I like, I sometimes solicit feedback from others. This gives me a chance to step back from my work and see it from another perspective. I am often refreshingly surprised to see the images that jump out at another observer, even ones I might be considering deleting.

You have a choice between numerous software programs for processing, editing, retouching, and managing your images. Nikon Capture, Adobe Bridge, Adobe Lightroom, Adobe Photoshop, and Apple's Aperture are all popular. Each has its advantages and disadvantages. Do your own research and find a system that suits you best.

The first step is to batch process the RAW files, by importing them in batches into Adobe Capture Raw, Nikon Capture, or a similar program. You can then adjust them simultaneously for contrast, color balance, or other factors. These programs work particularly well with images that are shot with a similar exposure and color tone. You can delete any images that are obvious rejects before saving them as processed files and save a lot of storage room on your hard drive.

Next, use an edit-viewing program, such as Adobe Bridge or Lightroom. These are simple but powerful tools for photo organizing, and browsing, keywording, and cataloguing your images. I separate my images into different scene settings that vary from one shoot theme to the next. I label the folders with the couple's initials or abbreviated versions of their names so they don't match any other folders in my files. This way I won't accidently mix in a folder of the same name from another client's shoot. For example: Joe/Elen at tree, Joe portrait, Elen portrait, Joe/Elen close-up details, Joe&Elen location, Joe&Elen walking in park, etc.

Then go through your rough-edit images closely, one at a time, for clarity, detail, expression, and exposure. Stop to mark or flag any particular favorites from each scene setting.

Scan Your Favorites

After I review all my film images, I'll usually choose a few of my selected favorites and make super-high-resolution scans for my stock agencies, large gallery display prints, or my portfolios. I make these 4,000 dpi scans with my Nikon Coolscan 9000. When I'm short on time I'll have my lab do it. Super-high-res scans are a bit more expensive than the standard scans. Standard scans suffice for my clients (and even my portfolios most of the time), but there is nothing like a super-high-res scan when you can afford it.

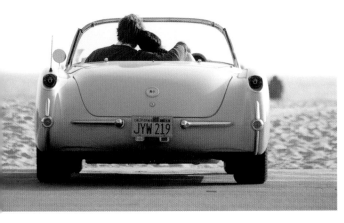

This is an example of an exception to the rule that retouching should always look natural. The goal of this image was to create a bright, kitschy, retro image. The sky was nonexistent on the day of the shoot, so I already knew I would be adding a new sky from my library of stock images later. The saturation was increased on both the sky and the original image of the couple in the car.

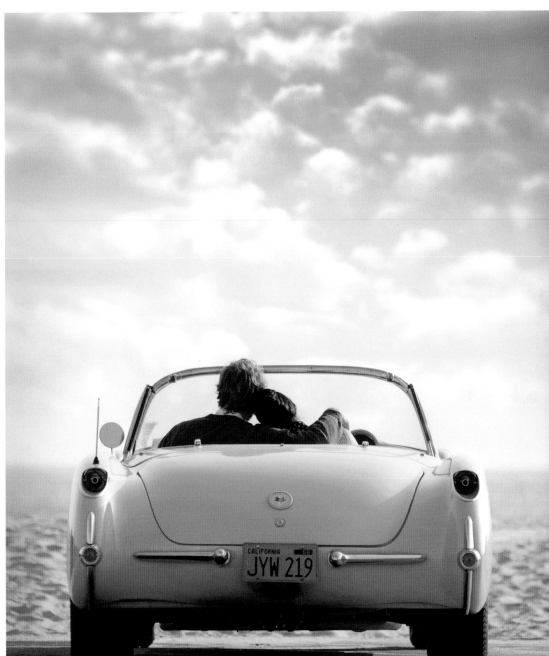

TAKE ADVANTAGE OF PHOTOSHOP

Once the images are organized, you can use Photoshop to work with those that may require some retouching (such as blending skin tones, reducing wrinkles, or retouching blemishes), image altering (such as removing distracting elements in the background or slenderizing a heavy body), or one final tweak for color tone or exposure.

You can also use Photoshop for image manipulation, but if you're relying on Photoshop instead of your camera to create a strong image, you don't need to be a photographer. Your goal is for your viewers to see your amazing images, not your amazing Photoshop skills. Don't get carried away with image manipulation unless you're intentionally creating a humorous or quirky image. Your images should look natural. If we can tell someone has had plastic surgery, it defeats the whole purpose, right? The same principle applies to retouching.

Whenever you use Photoshop for manipulation, keep a backup file (tif or jpeg) and a layered (psd) file of the image before making any changes. This will allow you to go back later and reduce or adjust any retouching should you or your client not like the results you have created. I once retouched a few moles for one of my clients, thinking she would want me to. She didn't (gulp!). She said the moles were a part of her and she wanted them back (so thank goodness I had a copy of the original file!).

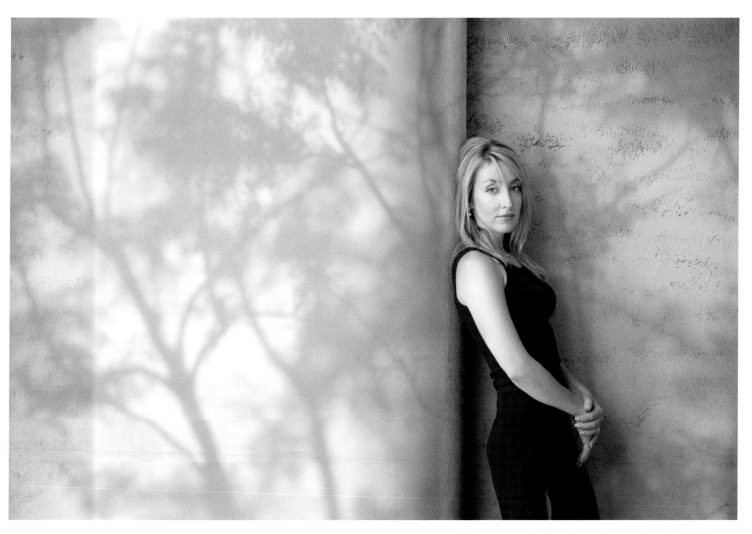

This is an example of overlapping images (Opposite, right) to create a more dynamic one (above). It's simple to do in Photoshop by simply dragging one image onto the other and choosing Multiply in your Layers options palette.

Nikon F100, 28–105mm Nikkor lens, Kodak BW400CN film, 100 ASA, 1/500 sec. at f/4.5, natural ambient light

Storing Your Images

Once you're done retouching and consider an image to be completed to your satisfaction, back it up twice for safekeeping (RAID and other storage systems will automatically back up files to multiple drives for you). Like all equipment, hard drives can wear out over time. Periodically backing up data from one hard drive to another, newer one provides some insurance. Follow manufacturers' recommendations to place your drives in properly ventilated areas and turn them off from time to time. This allows them to cool down and eases wear and tear on the mechanical parts.

RETOUCHING

I try to shoot in a way that gives me an image that's as close to perfect as possible. This not only reduces the amount of retouching to do (and time is money!), but it creates a more natural-looking image.

However, some things are beyond our control. A dead patch of grass, a telephone pole behind the person's head, or fine lines and blemishes on a face might create distractions, and small adjustments can make significant changes. As a rule of thumb, remove, soften, darken, lighten, or adjust anything that is competing with your main subject. It doesn't matter if it is natural or not. If you have a great image, but a distracting patch of sunlight happened to hit a leaf on a tree, get rid of it.

Once I have chosen the final image selections I intend to give my clients, I go back and review each one closely one last time and make any final retouches. I squint at the image and notice where my eye goes first. If my eye goes straight to a bright spot that is not the intended main subject of the image, then something is wrong. The tool I use the most often is Photoshop's Healing Brush, set on the Replace option for best results.

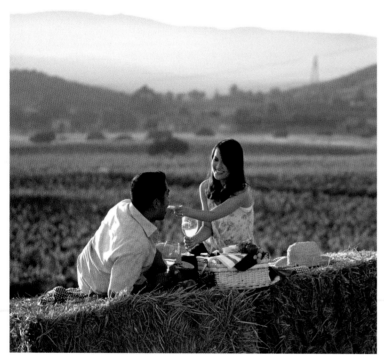

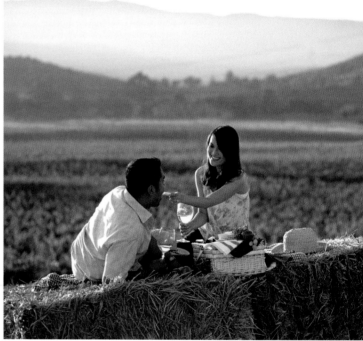

This is another example of a how small changes can make big differences. In the image on the left, haystacks in the background behind the woman's head were distracting, undefined elements in the scene. Removing them with the Healing Hand tool cleaned up the image significantly and shifted the viewer's eye immediately to the main subject.

Nikon F100, 105mm Nikkor lens, Kodak BW400CD film, 200 ASA, 1/250 sec. at ƒ/2.8, natural ambient light

ADJUSTING COLOR

All the images from your photo shoot should have a consistent color tone (or temperature). This applies to sepia-toned images as well. Unless you are intentionally seeking to create a lonely, cold, fashion look, a healthy warm glow is desirable. A warm image just feels better, and people look better in this tonal range.

Be on the lookout for problem tones. Cool-toned images tend to make a person appear unhealthy, while reddish tones, especially around the face, can make a person appear sunburned (or alcoholic!).

You can warm up an image simply by adding a bit of yellow (and sometimes red, if the images are too cyan) to an otherwise cool-toned image in your color-balance palette. A minor adjustment like this can change the emotional feeling of the entire image.

If you are having a lot of trouble adjusting the tones and can't seem to get it right, try converting the image to black and white and using the Colorize palette to add a bit of warm sepia-tone hues. Either way, the objective is to avoid overdoing it and to create a consistent, natural, flattering look within the entire group of images.

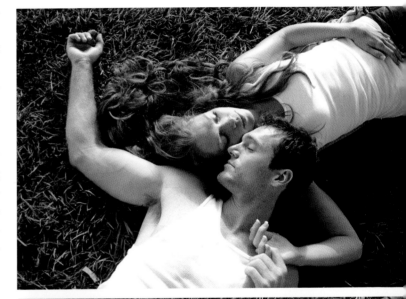

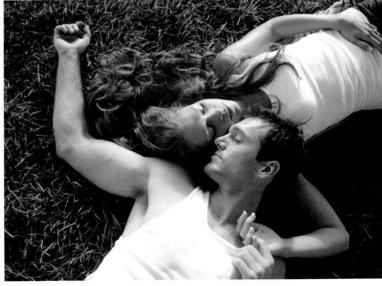

This is an example of a minor color adjustment. I neglected to put a warming filter on the lens when shooting this image. Since open shade areas tend to record cold (blue tones), I had to warm up the image in Photoshop. This was easy. I just added a bit of yellow to the mid-tones and a little cyan to the shadow areas to give the bottom image a more pleasing appearance.

Nikon D3, 80–200mm Nikkor lens, ISO 200, 1/400 sec. at ƒ/3.2, natural ambient light

ENHANCING SKIN

You will soon learn about the tools and filters that help you achieve optimal skin effects. The goal is to make your subjects look healthy and refreshed as though they have just returned from a week at a spa, not a plastic surgeon's office. That is, don't over do it. When retouching a face, it is important to zoom in as close as possible to work on the specific area. This gives you more precise control for a more natural appearance. When retouching a man's face, you will want to maintain his masculine, rugged appearance, so the trick is to remove any blemishes or unwanted stray hairs without making his face look too polished and soft.

A Photoshop plug-in filter called Picture Code Noise Ninja, while designed to reduce noise, can blend blotchy tones, soften pores, and reduce fine lines. The Rubber Stamp is another tool that, when used sparingly and lightly, is helpful when blending blotchy, uneven skin and softening pores. The Healing Brush copies tone and texture from one area of your image and places it where you choose. The effect is natural, so the Heaing Tool is ideal for retouching skin.

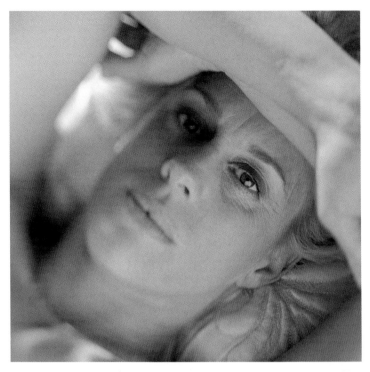

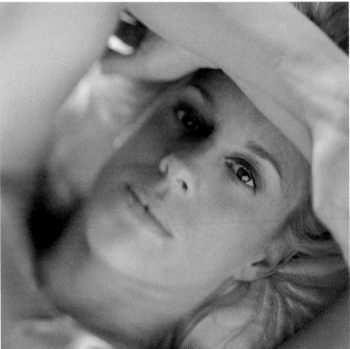

This woman had beautiful skin but a few very fine lines around the eyes and forehead (top). We both agreed the retouching would be minimal and I would go easy—she didn't expect nor desire to look like a twenty-something girl. That would be ridiculous. She just wanted to look like a refreshed version of herself, and the Rubber Stamp tool did a nice job of softening the pores just a bit (bottom).

Nikon F100, 85mm PC Nikkor lens, Kodak 400NC film, 200 ASA, 1/250 sec. at f/2.8, Lowel incandescent hot lights

BLURRING A BACKGROUND OR OTHER ELEMENTS

Gaussian, Smudge, Healing Hand, Focus Blur, Blur, Burn, and Dodge tools can all be used to soften a background or other elements in your image that you want to appear to be out of focus. To create a successfully convincing effect, it is important to feather the edges of your selected area by using the Lasso or Marquee tools. Another more advanced option is to create a layer mask and use the Gradient tool to gradate the selected area.

Once you have blurred the area to your liking, it is imperative to add some grain or noise to the selected area. Each image has a certain amount of grain and/or noise (even digital images, especially those taken at higher-resolution settings), so you want the area you've manipulated to match the surrounding, unaffected areas. If you don't, the image will look inauthentic and unconvincing. The grain and noise filters can also be used to try to make a digital file appear more like real film, giving it depth, dimension, and texture.

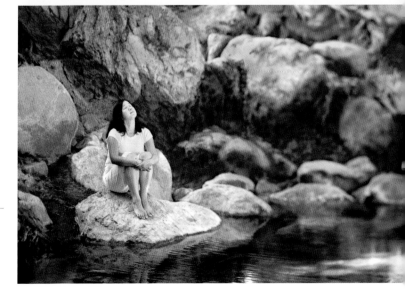

This is an example of a retouched background. Comparing the original image (top) and the retouched image (bottom) you will notice that many elements have been removed from the background. Shadow areas have been lightened (using the Dodge tool) and highlight areas have been darkened (using the Burn tool). These were mostly competing highlights that distracted the viewer's attention away from the main subject. I used a combination of tools to retouch (Healing Hand, Blur, Gaussian Blur, Burn, and Dodge).

Nikon F100, 80-200mm Nikkor lens, Kodak BW400CN film, 100 ASA, 1/250 sec. at *f*/2.8, natural ambient light

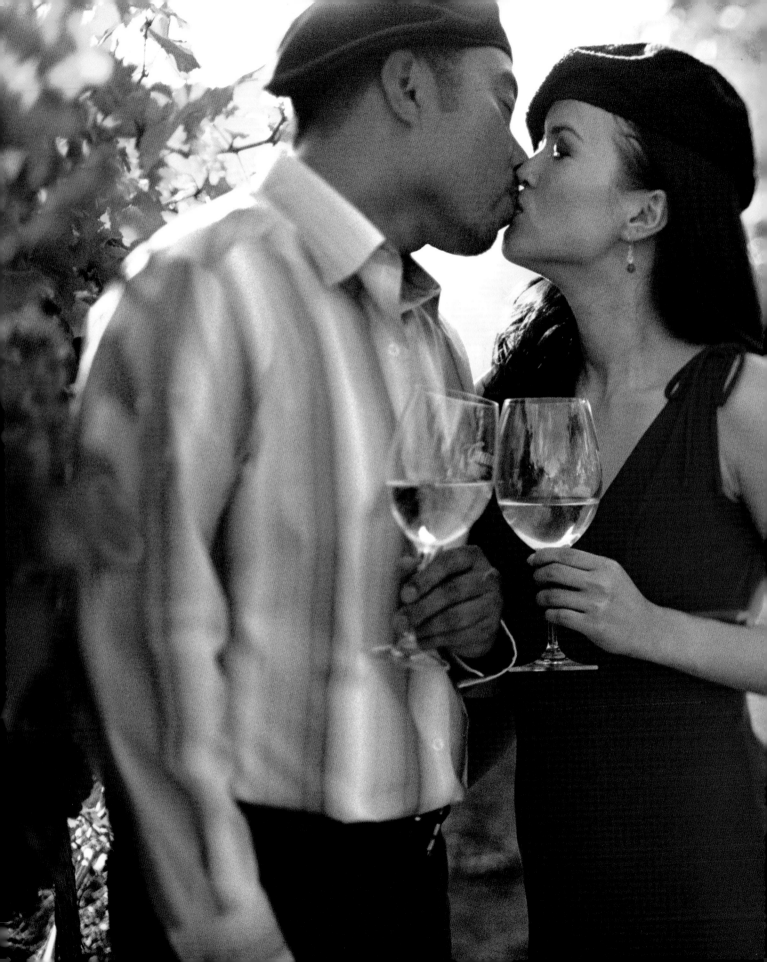

Chapter 8

TURNING YOUR ENGAGEMENT IMAGES INTO PERSONALIZED PRODUCTS

Now that you've made incredible images, you'll want to present them in an incredible way. This is another opportunity to "wow" your clients to make sure they are ecstatic about your work. Even if you're only delivering digital files, you still have a great opportunity for a dynamic presentation. How about making a unique CD cover? For larger jobs that include both prints and digital files, you can create a unique, theme-oriented presentation box that doubles as a "thank-you" gift to your clients—something that's sure to take their breath away and guarantee they will always remember you.

CREATE A
PRESENTATION BOX

A hot-glue gun, Krazy Glue, scissors, fishing wire, and thumbtacks or a staple gun are all you need to create a one-of-a-kind presentation. My package designer, Christine, and I are constantly on the lookout for gift boxes, hatboxes, and unique, inexpensive items we can recycle into one-of-a-kind packaging—from fake fruit and costume jewelry, to wine bottle crates and vintage silk scarves. We're never short of ideas to create these amazing boxes. Most of these items can be found at arts and crafts shops, second-hand boutiques, and inexpensive retail stores.

Once you find just the right box, you can embellish it with your own touches as shown in these images. When you're ready to pack the box, fill it with potpourri, fake moss, straw grass, hay, or any artificial packing product that will cushion but not stain or otherwise damage the prints. I once used dry popcorn as a box filler to enhance the movie theme of the images I was presenting.

If you prefer to mail or messenger the box, wrap it like a gift and place it in a padded shipping container. I always include a handwritten note on my letterhead stationery or logo note cards, saying something like, "What an incredible experience we had shooting your engagement session! Hope you'll enjoy these for the rest of your lives. Can't wait for the wedding day when we'll get the chance to make even more amazing images! Talk soon, Elizabeth."

If your clients prefer to pick up the box themselves, you can create a special "drop box" placed discreetly outside your office (I place a waterproof ice chest outside my door). This allows clients to come by at their leisure without having to schedule an appointment or disturb you in the middle of your workday.

Opposite: Even when presenting my clients only with digital files, I like to design a unique CD cover. You can design similar covers in Photoshop, In Design, or Illustrator.

Top: This is a box I created for a beach-themed shoot. I used a wooden box, decorated with seashells that I secured in place with a hot-glue gun. A large seashell became the handle for the lid, and I filled the inside of the box with small, loose seashells and sand as padding. I used Elmer's glue to write "Love" on the front of the box, sprinkled sand over the top, let it dry, and brushed it off.

Bottom: This is a simple box I created for a vineyard-theme shoot. The obvious choice was to use a wine box and include a bottle of wine. The artificial grapes, artificial lavender, and straw-like filler to pad the box all came from a large crafts shop.

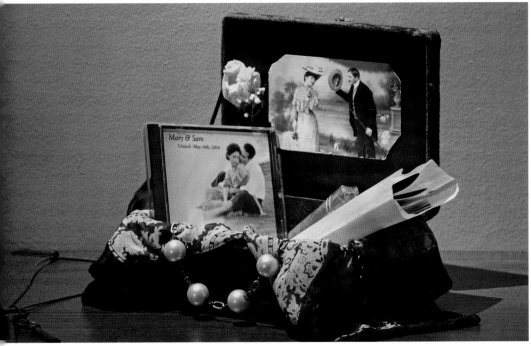

Above: This box complemented a shoot in a wooded canyon. We found the wicker basket, fake flowers, potpourri, and miniature watering can at various crafts and home-goods stores. The fake green apple was the perfect handle, secured with a nail and a washer inserted into the apple from inside the lid.

Left: To present a vintage theme shoot, I used a velvet jewelry box I found at a garage sale and padded the inside with a silk scarf and a fake pearl necklace from a secondhand store. We even included the cigar we'd used as a prop during the shoot.

OFFERING A LA CARTE PRODUCTS

Planning a wedding is stressful, and clients will be relived to know that you are presenting a one-stop shop that will save them time (and money). Craft items are also fantastic marketing pieces, since each will discreetly display your company name and website.

With each new client comes an opportunity to introduce products and services they may have never even considered. For example, a basic one-sided save-the-date card with an image on the front might only take you thirty minutes to design and cost less than fifty cents for ink and paper (if you print them yourself), but you might sell them for three or four dollars apiece. More labor-intensive items, like a slideshow presentation, might take you a few hours to design, but you could charge eight hundred dollars! The profits add up quickly.

You don't need to be a professional graphic designer; with only basic Photoshop skills, you can do easy design layouts in no time. In fact, you will be surprised by how easy and cost effective it is to design and print an array of craft items yourself. Here are a few of the items you might consider offering clients as part of your a la carte services:

- Save-the-date cards
- Thank-you notes
- Wedding invitations
- Guest books
- Custom stationery
- Canvas photos
- Framed photo montage boards for guests to sign
- Photo albums
- Coffee-table books
- CD music jackets
- Digital slideshow presentations
- Framed fine-art prints gallery photos
- Calendars
- Christmas cards and ornaments
- Photo mugs, mouse pads, magnets, playing cards, T-shirts, plates, etc.

To create these items, all you need is a computer, a color printer, fine-art digital papers, and a sharp paper cutter. I simply drag and drop my favorite engagement image into a layout, add some text, and print it. That's it. I always make a few test prints first on plain paper before the final master. If clients want multiples, show them the master print first for their approval before printing the remainder of the order. If the card will be folded, you can buy a scoring blade at any art supply store; it will give you a clean, professional fold line. If the order is for several hundred units, consider having it printed, scored, and folded by your local print shop or an online service company.

When estimating the cost of the job, remember to include all of your time and expenses. Don't feel guilty about charging your clients extra for all this. You are not only providing creative design and printing services but also handling the entire process so they don't have to. For time-starved couples, this is a blessing and a huge burden off their shoulders.

To price the items, double or triple the wholesale total costs (depending on the amount of labor involved), although you should also gauge what the market can bear. Shown here are some of the products and services I offer, with the time and expenses listed for each. These include tax and shipping costs. When I use an online printing company I always have them shipped directly to me. I inspect the product, remove all receipts and invoices, then mail or messenger it to the client. For obvious reasons, you don't want your client to know your supplier contacts and wholesale costs.

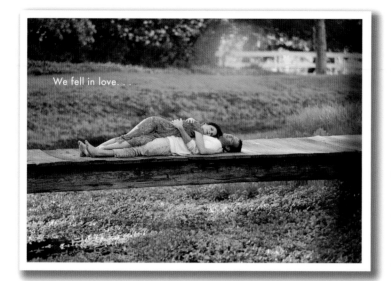

We fell in love. . . .

Please reserve the date
for the marriage of
KRISTIN RILEY & ROB MACELIANO

Oct 17th, 2005
Callabassas, CA

Formal invitation to follow
For more info visit our website at:
www.kristinandrob-wedding.com

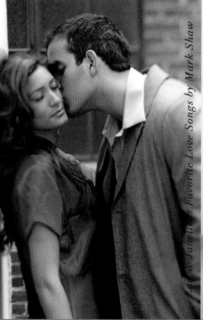

Luis & Janellie's Favorite Love Songs by Mark Shaw

1. Truth 4:44
2. Forever In Your Soul 3:31
3. Dream Walking 5:48
4. Getting Over You 4:14
5. Reaching 7:04
6. Loving YouBefore 4:38
7. Don't Stay Forever 5:45
8. Sweet Love 3:52
9. Walking In Circles 3:57
10. Goddess In White 4:26

Photography by Elizabeth Etienne
Graphic Design by Elizabeth Etienne
www.eephoto.com 310.578.6440
Music by Mark Shaw
All songs Copyright Mark Shaw 2005

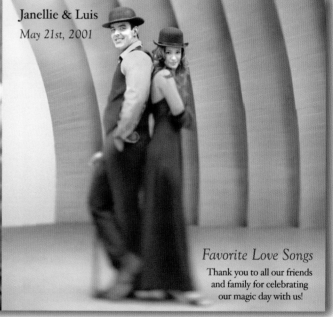

Luis & Janellie's Favorite Love Songs by Mark Shaw

Janellie & Luis
May 21st, 2001

Favorite Love Songs
Thank you to all our friends
and family for celebrating
our magic day with us!

Above, top: I designed this simple, double-sided save-the-date card in Photoshop and had it printed at an online service printer called ModernPostcard.com. Wholesale cost for 250 postcards: $150; resale price to client: $475 ($100 design fee + $375 for postcards at $1.50 each); time required: one hour (design layout, image upload, order); total profit: $325.

Above, bottom: Music CDs using the couple's engagement images make excellent, inexpensive gifts for guests. The white wall in the image provided the perfect open space for text. When shooting, look for off-centered compositions with blank space where you can add text for postproduction craft items. Wholesale cost for 250 CDs: $388; resale price to client: $1,320 ($450 design fee + $750 for 250 CDs at $3.00 each + $120 shipping and handling); time required: under seven hours (design layout, image uploads, order, jacket insert into plastic cases, packing, and shipping); total profit: $932.

Opposite, top: Wedding guests were encouraged to write a message to the couple on the back of the screen.

Opposite, bottom: This is a life-size three-tier canvas screen created with one of the couple's engagement images. It was positioned behind the wedding cake. It was approx 52 inches x 68 inches. Wholesale cost: $475; resale price to client: $1,200; time required: two hours (color print proofing and canvas supervision); total profit: $725.

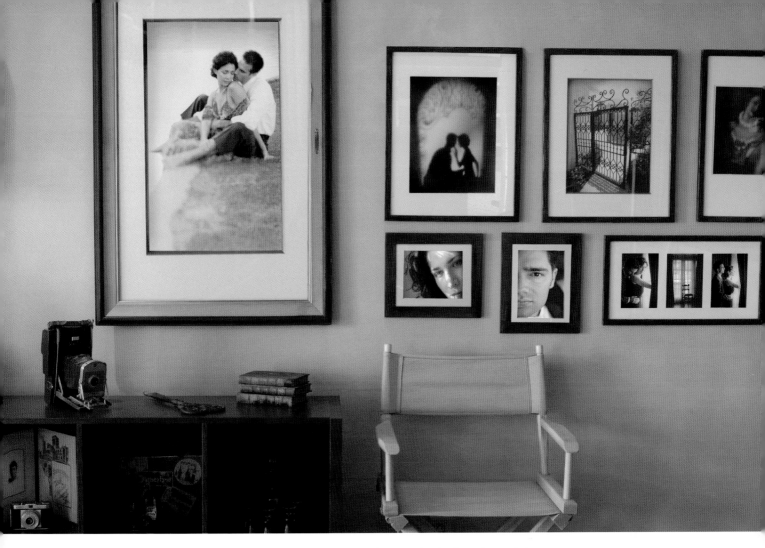

Opposite, top: This is a digital slideshow presentation using engagement images. It could also include a chronological series of images of the bride and groom from adolescence through today and old letters or memorabilia. It's great background entertainment during cocktail hour, dinner, or speeches. The service includes scanning and retouching of original images and arranging of all images into a specific order set with special transitions and moving text, etc. The price includes all equipment: digital projector, system assembly, and supervision. Wholesale cost: digital projector rental: $150; resale price to client: $1,500; time required: twelve hours; total profit: $1,350.

Opposite, bottom left: This is a calendar we created with images from the engagement shoot and printed with an online printer (see page 156). Your profit on a product like this is going to be minimal, but a calendar is an excellent way to promote your work. Wholesale cost: $25 (printing, with tax and shipping); resale price to client: $100; time required: an hour and a half; total profit: $75.

Opposite, bottom right: This framed, matted photomontage board became an art piece for the couple's home. It was placed at the gift registry table and guests were encouraged to write a message to the couple directly on the matte board. You won't generate a lot of additional revenue from this product, but guests will love it. Besides, this provides an opportunity to promote your business (notice my business cards at the bottom right side of the frame).

Above: This is an example of a home wall gallery display using a variety of images from an engagement shoot. If you have an archival printer, you can save some money and print yourself, or you can go to a custom lab and have prints made. You will want to have a frame shop professionally mat and frame the prints. The estimate below is for prints made at a custom lab. Wholesale cost: $800 (eleven prints: $500, nine frames with mattes: $300); resale price to client: $1,600; time required: six hours (measuring the wall, selecting the pictures, driving to and from the lab, to and from the print shop, and to and from the clients' home); total profit: $800.

AN ENGAGEMENT SESSION . . .
in a Country Setting

You have a wide time frame for an outdoor shoot, from spring through autumn. In these seasons you are sure to find backgrounds of rich green grass, trees changing colors, and sun-dappled foliage. You don't need to travel to Montana to find a rural setting—the trees and meadows of a big-city park can easily suggest the countryside. Denim, wooden bridges, picnic blankets, old farm trucks, and animals all enhance the mood.

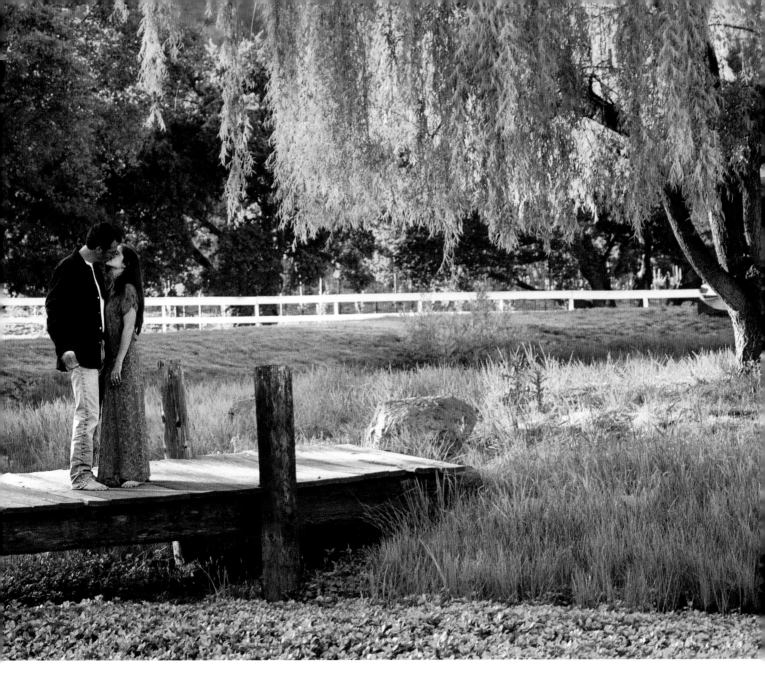

Opposite: This redwood hand mirror brings the autumn leaves into sharp focus, and the colors all work so well together.

Above: The off-balanced composition enables us to see more of the location, especially the beautiful weeping willow backlit by the warm, late-afternoon sunlight. Whenever I shoot film in open shade, I always use a warming filter (either my 81A for a soft warm effect or my 85B for a stronger, warmer effect). When I shoot digital, I immediately know to warm up my color temperature before I begin shooting.

Nikon F100, 28–105mm Nikkor lens, Kodak 400NC film, 200 ASA, 1/125 sec. at f/5.6, Tiffen 85B warming filter, natural ambient light

PREPARATION AND OBSTACLES: Some parks require permits for commercial/advertising shoots, but you'll probably get by without one. If questioned, simply explain that you are doing an engagement photo session and that the images are not being used for commercial or advertising purposes. Bug spray, pants, and long-sleeved tops may be in order when mosquitoes and other insects are out in force; this doesn't mean a couple might not want to wear something else, but they should keep a cover-up handy.

WARDROBE: Jeans, T-shirts, and other casual attire fit in well with these surroundings, while denim overalls, a prairie dress, and a flannel shirt can further enhance the outdoor theme. You might also want to experiment with elegant attire as a refreshing juxtaposition, if that suits the couple's personality. Think about colors that might complement the surroundings, such as orange or red to further enhance the autumn colors.

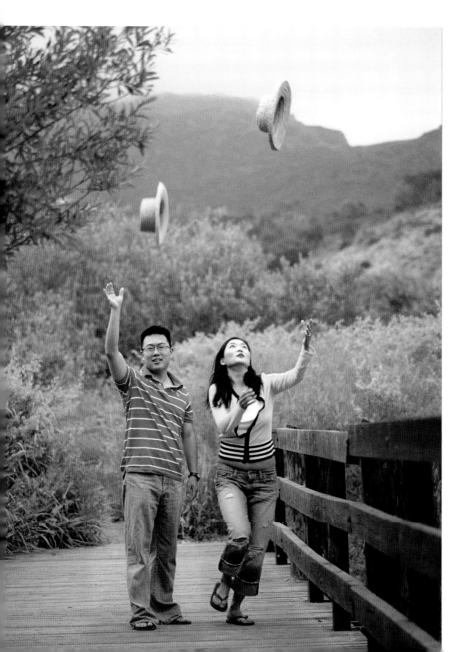

Left: Straw hats are easy to transport, and couples usually have fun with them. A wooden bridge surrounded by lush foliage was the ideal backdrop to this shot and makes the subjects pop. You'll encounter many such natural settings when you start scouting outdoor locations.

Nikon F100, 105mm Nikkor lens, Kodak 400NC film, 200 ASA, 1/500 sec. at ƒ/2.8, Tiffen 81A warming filter, natural ambient light

Opposite: The orange dress was perfect for this lush, green setting. Shifting the focus to the foreground of tall grass in the pond filled with lily pads, instead of focusing on the couple in the background, made for a more creative environmental image.

Nikon F100, 28–105mm Nikkor lens, Kodak 400NC film, 200 ASA, 1/125 sec. at ƒ/5.6, Tiffen 85B warming filter, natural ambient light

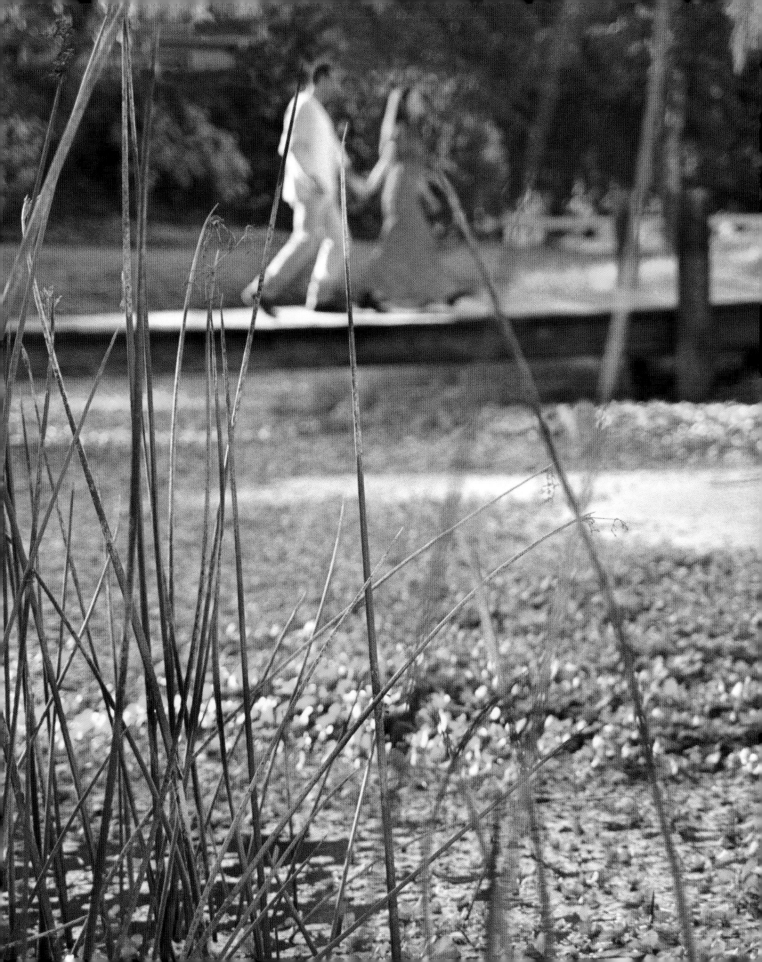

HAIR AND MAKEUP: For women, loose and wild works best. Keep makeup natural and minimal to match the environment.

PROPS: Finding the right props will be a part of the fun—an old truck, a pitchfork, straw hats, a picnic blanket, a wheel barrow, a hammock, an old boat, a swing, even a pig. You probably won't need too many props, as nature steals the show in these settings.

LIGHTING CONSIDERATIONS: As any outdoor photographer discovers, light is especially warm and appealing in late summer and autumn and in the late afternoon.

Opposite, top: The couple's work truck was the perfect prop to suggest a romantic tailgating party, and the wooden, suspended footbridge across a creek bed was another ideal outdoor setting.

For bridge: Nikon F100, 80–200mm Nikkor lens, Kodak BW-400CN film, 100 ASA, 1/125 sec. at ƒ/2.8, natural ambient light

For truck: Nikon F100, 105mm Nikkor lens, Kodak BW400CN film, 100 ASA, 1/125 sec. at ƒ/2.8, natural ambient light

Opposite, bottom: Shooting through the foliage with an off-center, shallow depth of field created the perfect vignette for the image on the right, and the close-up detail and colors of the autumn leaves in the image on the left created a good match for pairing the shots. Since the woman's hair was already a dominating color factor in the scene, I suggested the couple wear clothing that was not too colorful.

Left: Nikon D3, 105mm Nikkor lens, ISO 200, 1/400 sec. at ƒ/4.5, Tiffen 81A warming filter, natural ambient light

Right: Nikon D3, 640 ASA, 85mm PC Nikkor lens, ISO 640, 1/60 sec. at ƒ/2.8, Tiffen 81A warming filter, natural ambient light

Below: Combining people and animals is fun, and the pig in the mud at a ranch is a natural subject. The white fence and old wooden shed in the background immediately establish a theme for the image on the right.

Nikon F100, 105mm Nikkor lens, Kodak BW400CN film, 200 ASA, 1/125 sec. at ƒ/2.8, natural ambient light

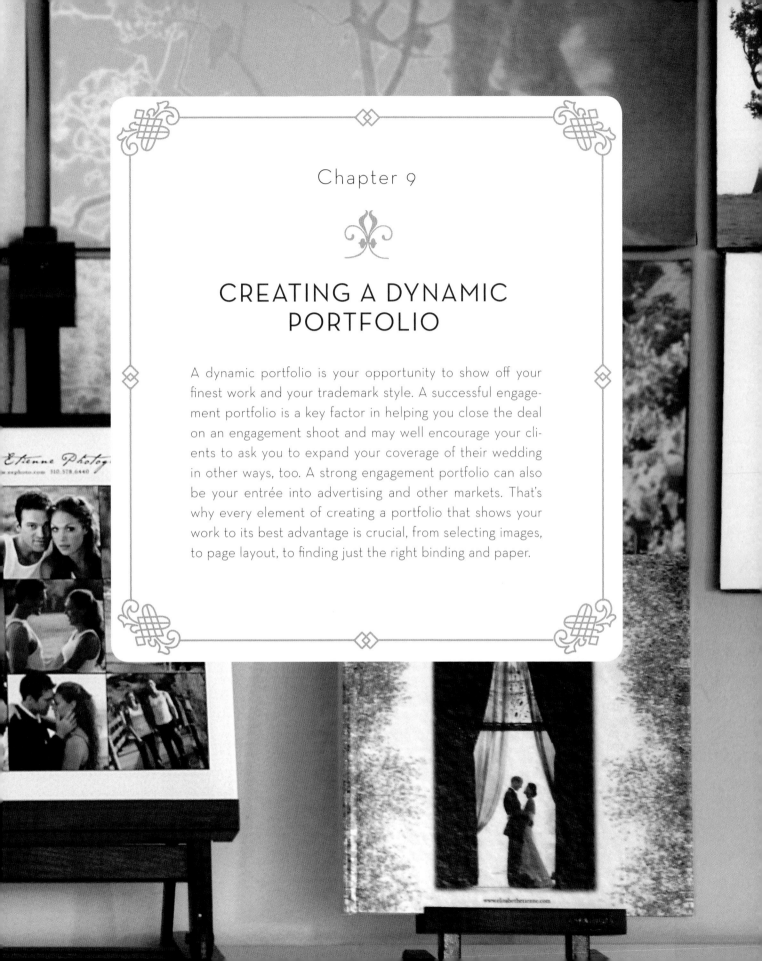

Chapter 9

CREATING A DYNAMIC PORTFOLIO

A dynamic portfolio is your opportunity to show off your finest work and your trademark style. A successful engagement portfolio is a key factor in helping you close the deal on an engagement shoot and may well encourage your clients to ask you to expand your coverage of their wedding in other ways, too. A strong engagement portfolio can also be your entrée into advertising and other markets. That's why every element of creating a portfolio that shows your work to its best advantage is crucial, from selecting images, to page layout, to finding just the right binding and paper.

SHOWCASING
YOUR IMAGES

Two golden rules apply when creating a portfolio. First, and most important, select only your "greatest hits"—no more than fifty to sixty of your best images. Your goal is to seduce viewers into wanting to see more, instead of overwhelming them with too many images.

Second, the collection of images should flow consistently throughout your portfolio, establishing a rhythm. Images from different shoots, with different themes and showing different subject matters, should all look like your work and reflect your style.

Show your collection to others and get their honest feedback. Ask them not to focus on their favorite images but on the overall feel of the collection you show them: Do the images flow together, like a series? If they answer yes, you are good to go. If not, ask your critics which images do not fit and which they would remove if they could.

If you are unsure about judging your best images, consider scheduling a portfolio review with a professional photography consultant. In just one ses-

sion, you will probably gain tremendous insight into your work and see it for the first time as the rest of the world does. This will help you see strengths you may have overlooked as well as elements upon which you can improve—a difficult thing for artists who are so emotionally attached to their work. I only wish I would have had a professional portfolio review when I was first starting out. It would have saved me many years of heartache and frustration.

The way your book looks is as important as the contents. It should reflect your personal style, be impressive enough to establish your credentials as a pro photographer, and be intriguing enough to entice the viewer to open it. Your book should be lightweight enough to hold effortlessly and toss about if need be.

Think outside of the box to find an unusual presentation, but this not necessarily an easy task. It is easy to fall into some wrong choices, such as a traditional wedding "album," which is durable but too formal and heavy, or a consumer drag-and-drop

book with a flimsy binding that can be produced online but usually has poor print quality that screams "amateur photographer." But do some searching, and you'll come up with options—maybe a large leather portfolio book or an affordable hardbound book with fine paper and a contemporary feel.

Here are some more general guidelines for putting together a portfolio:

- Show a mix of color and black and white, close-ups and long shots, vertical and horizontal images. This helps prevent your book from looking stagnant or redundant and presents a very polished, high-end magazine- or advertising-quality appeal.

- Keep note of the simple things, like color hue and contrast range. Do all the images present a warm feeling, or are some on the cold side, while others are neutral? They can vary, but the key is overall consistency—they should all clearly reflect your particular look and style. Think of a movie, in which the characters might undergo a variety of emotions, from intensely serious to funny and lighthearted, but they still have a distinct personality.

- When designing the portfolio, keep framing and borders in mind. If you have a one-inch white border around one image, then you should have a one-inch white border around the other images as well.

- Create a few design templates and randomly repeat them throughout the book. For example, a horizontal image might be in the same place each time it appears on a vertical page. (I place mine exactly one and a half inches below the top edge of the page.)

- If you want to mix it up, do so intentionally with rhythm, as in a song. You might have two pages with full-bleed images, followed by two pages of montages, then one full double-page image. This style could repeat several times throughout the book, creating a rhythm.

- Consider adding "prop images" to your pages—a sky with perfect clouds, a pair of trees symbolically standing together, an antique mirror, maybe a wine bottle with the label prominently displayed (as if it were taken from an ad campaign for a winery). These might be from another shoot or a selection of vacation shots. Adding a prop image to the page layouts can give an engagement portfolio an editorial or advertising appearance and help land a shoot for a magazine or ad agency.

This double-page spread features a checkerboard layout, which helps the mind's eye absorb the five different images without becoming confused. It also helps to use a mix of close-ups with long-distance images side by side.

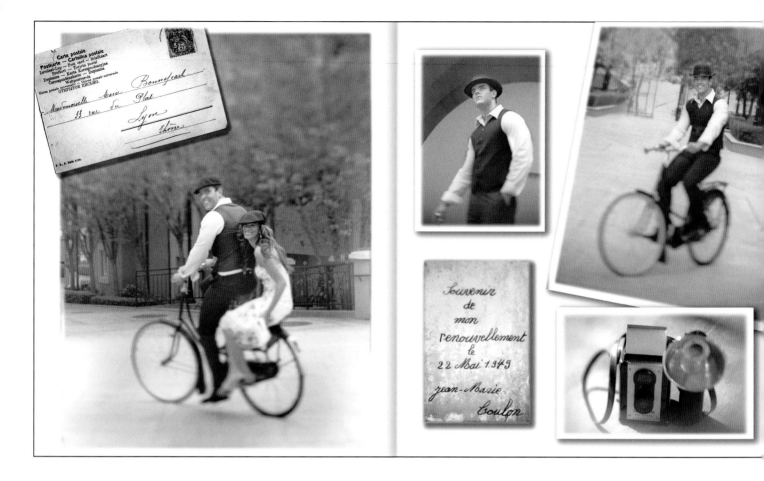

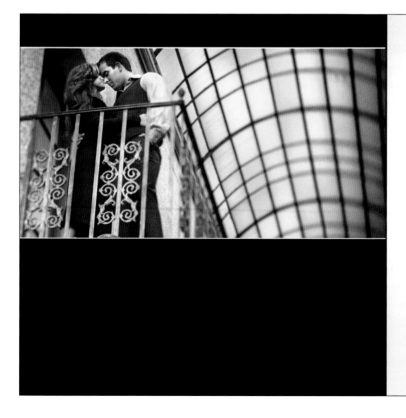

The day we spent together during our engagement shoot was one of the most romantic days we've spent together in awhile especially with the craziness of planning the wedding. We both said that if a single image didn't turn out well it was Ok because we just loved the day. When we got the images back we both just cried. They were far beyond what we ever expected. I dont know how you do what you do but youre simply the BEST. Cant hardly wait for the big day!

Lisa & Dan

Opposite, top: This is a double-page spread with a unique layout design for my vintage book. I incorporated still-life details of antique postcards to further enhance the engagement session's overall theme and then added a drop shadow beneath each of them to give the page a more three-dimensional look.

Opposite, bottom: This is a double-page spread from my engagement image book. While I normally prefer clean white backgrounds, I sometimes use a black background with a high-key image, such as the one shown on the left side of the layout. The testimonial quote fit perfectly in the unused space in the vertical image at right. Displaying testimonials is a way to establish credibility with your clients.

Above: This thumbnail page contains some of the image spreads from one of my portfolio books. All of my books include a title page, biography page, and a contact sheet page with small thumbnails of each image spread in the book. These pages are placed at the end of the book, giving the viewer a final recap of all the images they have just seen.

Right: People always like to put a name with a face. This is the biography page I place at the end of each book, changing a paragraph here or there to cater it to the particular book's subject matter. Notice that the first line of each paragraph is capitalized. This highlights the key significant facts and makes it a faster and more interesting read for the viewer.

Photographer
Elizabeth Etienne's
TIMELESS LIFESTYLES

From the cobblestone streets of Paris to the sandy beaches of California she now calls home the photography career of Elizabeth Etienne has taken her around the world and back. She attributes both her French-American up-bringing and her many years living in France to the romantic, soulful style of her work.

TRAVELING & WORKING ON LOCATION:
Speaking 3 languages; a strong comprehension of others she is able to travel to almost any exotic location, negotiate the surroundings, people and terrain quickly while meeting tight scheduling and budget restraints. She is also known for her ability to "re-create" various locations locally to appear as though they were someplace else in the world.

FILM or DIGITAL:
Her team of digital experts enables her to upload casting session talent and shoot production images to the web in minutes!! This is ideal for out-of-town art directors & clients, saving time & money! In addition she is also fully equipped with the latest latest state-of-the-art computers, scanners, cinema display screens and a master digital retouching team, (including herself!). She and her team are prepared to supply the client with everything from rough comp layouts to complete image variations.

HER 'FAMILY' OF ASSISTANTS:
Many of her assistants have been working with her for years. They are able to intuit everything from her trademark lighting to film or digital card loading, processing and coding. This seamless team system makes productions effortless and easy-going for the Art Director, client and crew..

HER SURFBOARD and HER DOG!
When she isn't traveling for work or pleasure, or collecting another vintage camera to add to her collection, she can be found ocean side surfing the waves at her California beach front home.

Elizabeth Etienne's passion for photography began at age 14 with her first real camera. She became the "band" photographer for her first boyfriend's rock group in the early 80's, got hooked on the thrill of image-making and went on the graduate with honors from the prestigious *Brooks Institute of Photography* in Santa Barbara, CA. in 1989

Elizabeth has always been fascinated with "Timeless" images. In 1975 after the death of her father when she was only 10 yrs. old she began searching for clues to her family's past. When she discovered a suitcase full of old family photographs she became intrigued with these images. Staring at the stoic expressions of her ancestors, drifting back to a time before cell phones computers, and traffic; a time when we actually sat and listened to one another, there seemed to be so many questions one might ponder: Were these people happy? What were the important issues of their life at that time? . . . Did they suffer? These images evoke a quiet romance, a hush you can hear, a whisper in the silence. Elizabeth Etienne captures this silence through her photographs and that make us stop, listen and wonder. . .

Elizabeth Etienne was born in 1963 in a small suburb of Chicago. Her extended family of over 200 cousins and relatives that still reunion in the north woods cabins around a lake campfire are most known for their master "story-telling" abilities. Much of her work is often subconsciously inspired from these campfire tales and childhood memories. Etienne's work has been featured in *The Times Journal of Photography, PDN, Rangefinder.* and *Peterson's Photographic*

Elizabeth Etienne behind the dark cloth of her large format camera. Versailles, France

Elizabeth Etienne Photography
www.etiennephoto.com 310.578.6440

EXPAND BEYOND ENGAGEMENT IMAGES

Once you've created a portfolio dedicated exclusively to your engagement images, you may want to think about creating more portfolios with different themes to present to advertising agencies. Agencies love to see slick, stylized portfolios that clearly define a photographer's style, and all the experience you've gained from shooting magnificent engagement images may well prepare you to photograph a professional ad campaign.

Since I have an extensive image library by now (which includes everything from portrait sessions and travel to fine art, ad campaigns, and interiors), I could create four separate portfolio books—one exclusive engagement portfolio to show couples and three advertising books to present to ad agencies. One is dedicated exclusively to vintage images and includes shots from my vintage engagement sessions, as well as other vintage portraits, vintage-styled ad campaigns, and personal fine-art projects. Another is dedicated to luxury lifestyles and includes elegant couples, beautiful interiors, travel destinations, personal projects, details and tear sheets from former published work—targeted toward the travel, leisure, and hospitality industries. A third book features more casual lifestyles and includes fun-loving couples in rural settings, as well as portraits of kids, families, seniors, rural travel essays, and stock and existing ad campaigns, all targeted toward the insurance, pharmaceutical, and healthcare industries.

CHOOSING IMAGES
FOR YOUR WEBSITE

Your website can provide you with space to showcase images you may not have room to include in your portfolio books (remember, those are limited to fifty or sixty images). While you may probably repeat some of your favorites in your portfolio books and website galleries, you can still present them in different ways. This will give your clients and potential art directors a fresh and more expansive view of your body of work.

Opposite: This double-page spread landed me several ad campaigns for vineyards. The image of the couple on the bicycle was also chosen by my stock agency for inclusion in their library.

Below: Here is an example of one of my website image spreads. I took advantage of my website's very horizontal format and created a layout to match. I found this stamp on a letter from a long-ago Italian boyfriend, scanned it to a digital file, and dropped it into the layout. I call this "Italian Madonna."

Chapter 10

USING YOUR IMAGES TO EARN
RESIDUAL INCOME

The money you generate from an image over and over again is referred to as residual (or repeat use) income, and there are many ways you can create this ongoing revenue stream. Your work as an engagement photographer lends itself to two main sources of residual income—stock photography and the art market. Many of the images you create, and not just those of smiling couples, may have a place in these markets; both present you with rewards and new opportunities, along with new challenges. While there are no hard-and-fast rules for success in these arenas, the one rule is to continue doing what you do best: taking great images.

STOCK PHOTOGRAPHY

Stock photography refers to images of a certain subject matter that can be licensed (rented) by anyone repeatedly for a variety of uses, from advertising to greeting cards and everything in between. The arrangement offers the end user the convenience of having a large collection of images from which to choose and eliminates the need to hire a photographer to shoot a similar image. You benefit, too, because you can make money off your existing images.

By the mid-1980s, stock photography had become a specialty in its own right. The demand for images was huge, and the available selection was very limited. This "supply versus demand" equation drove stock image license fees up to very high levels. One of my single images licensed for more than $15,000! Stock agencies and stock photographers started popping up everywhere. As competition increased and image libraries filled, fees dropped rapidly and image-quality guidelines tightened. The image that was originally licensed for $15,000 in the early 1990s could now be had for $300 or less! Larger conglomerate agencies bought up small boutique agencies and the industry changed dramatically.

Money can still be made in stock photography, but you need to have the right images—they need to be unusual, dynamic, and in demand. Agencies are overflowing with images of couples walking along the beach at sunset holding hands; they do not want to stuff their files with more of the same, no matter how magnificent your shot is.

The images that are in most demand offer something newsworthy or portray a subject matter in a unique way. As society changes its views on various issues, the demand for certain images increases, such as those of ethnic and mixed-race couples doing a range of activities. Images of perfect-looking Caucasian couples are plentiful. Ask your agency for a current needs-and-wants list.

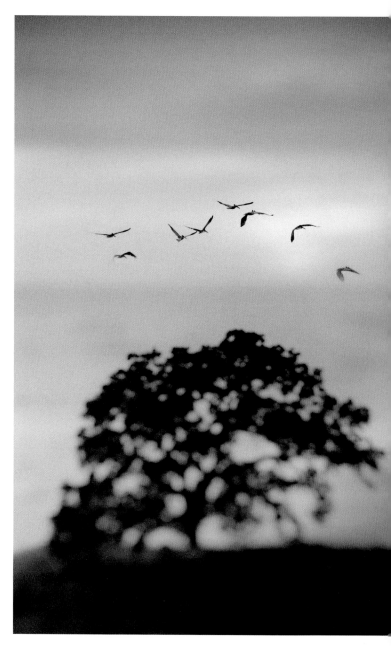

While location scouting for an engagement session, I saw this amazing tree standing by itself. I later photographed this formation of birds and was able to merge the two images digitally. Potential stock images are everywhere; you just need to keep your eyes open whenever shooting.

Nikon F100, 105mm Nikkor lens, Kodak 400NC film, 200 ASA, 1/60 sec. at f/2.8, natural ambient light

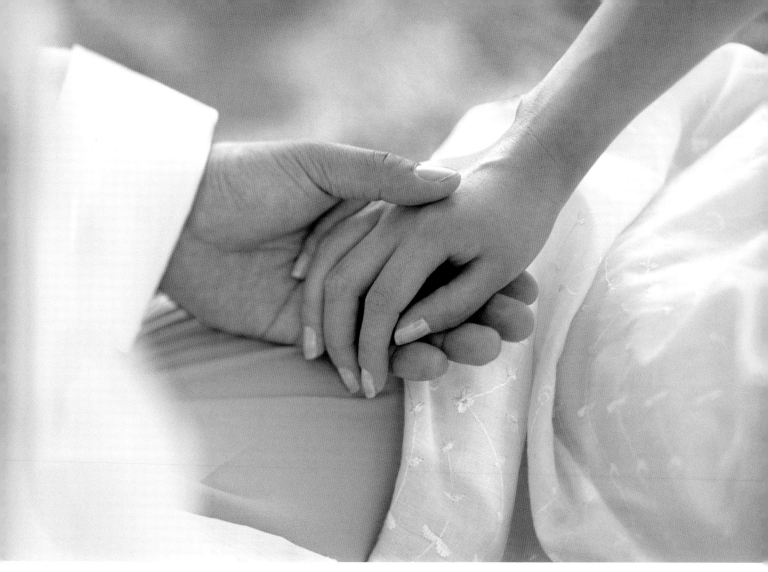

Stock agencies love symbolic, fine-art/journalistic images, such as these hands, and these are images you can easily create.

Nikon F100, 105mm Nikkor lens, Kodak BW400CN film, 100 ASA, 1/250 sec. at f/2.8, natural ambient light

Licensing Arrangements

Stock images are generally broken into two basic categories: royalty free (RF) and royalty managed (RM). Some agencies will assign your images to one of these categories or offer you the opportunity to choose yourself.

RF images are available to users for a fraction of the cost of RM images but offer no exclusivity. This means anyone can use an RF image anytime, anywhere, for a nominal one-time fee. Your image can be purchased numerous times, but the licensing fees are usually very low and you may only earn a few dollars for every sale.

RM images offer more exclusivity but are much more expensive for the purchaser, and this generally results in far fewer sales. Typically, larger companies wanting to establish a brand identity through images will choose an RM image because they want an image that no one else has used. The price to license an RM image is defined by the file size of the image (i.e., small, medium, large), the duration of the license time (e.g., six months, one year, five years, or unlimited), the region where it will be used in (local, regional, national, or global), and the application (web ad, newspaper or magazine ad, billboard, greeting card, calendar, book cover, etc.).

With either licensing arrangement, the photographer usually gets 40 to 50 percent of the sale price. Some stock agencies may also purchase your images outright for a one-time flat fee with rights to use these images in any way they please without paying your any additional royalties; this practice is becoming less and less common.

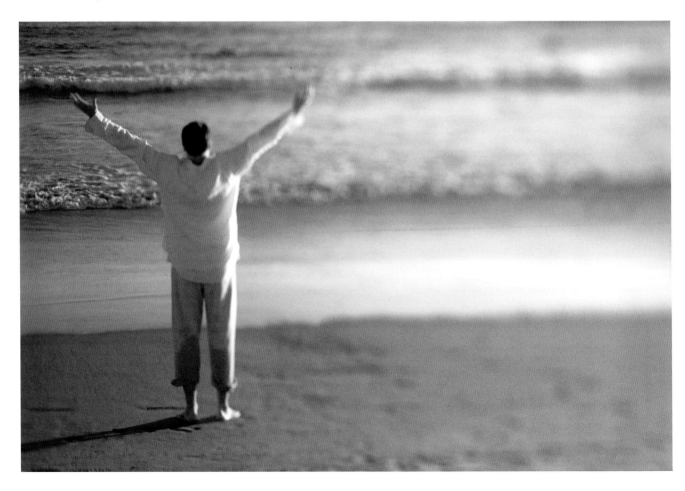

Opposite: This is another versatile engagement image, as it represents many metaphors (health, happiness, freedom, retirement, success, etc.). Stock agencies are always looking for images that include space for text, making this left-balanced composition all the more marketable.

Nikon F100, 85mm PC Nikkor lens, Kodak BW400CN film, 100 ASA, 1/500 sec. at ƒ/2.8, natural ambient light

Above: I always include image variations with my submissions to my stock agencies. Adding a dramatic sky to the image at left gave more options to the buyer.

Nikon D3, 80–200mm Nikkor lens, ISO 320, 1/500 sec. at ƒ/4.5, natural ambient light

Photo Releases

Releases are required for all images that display a recognizable person, property, or pet. Parents or a legal guardian of a subject who is under the age of eighteen must sign a special minor model release. A release allows the photographer to use the image for almost any application without further notice. The only exclusions would be negative-related products or services (alcoholism, teen pregnancies, suicide, sexually transmitted diseases) or any other uses that would display the person contained in the image in an unflattering or defamatory light.

Usually, you'll approach your clients with a release form after the engagement photo shoot. By this time, you will already have established a rapport with them, they will love your work, and they will probably be open to the idea of possibly having their "fifteen minutes of fame" if their image is used for a greeting card or an ad campaign. Your clients will probably be eager to comply. While it's fine to share the excitement, it's also only fair to point out the drawbacks: There are no guarantees that their images will ever be used, and this is not a big moneymaking venture (couple images are not in great demand, nor do they fetch top dollar). In some cases, I will sign a special payment agreement stating that I will share 50 percent of the proceeds with the couple, when and if an image is sold.

How to Choose a Stock Agency

Choosing the right stock photo agency is tricky, and the decision should not be made in haste. While most agencies are honest and ethical about reporting images sales to their photographers, a few are not and take advantage of artists in any way they can.

Be selective and cautious, and do your research. When considering an agency, ask other photographers who are represented by the agency how they like working with the agency and if they feel the agency is ethical when it comes to paychecks. You can also join the Stock Artist Alliance (SAA), the only trade association focused exclusively on the business of stock photography. SAA supports stock photographers through a discreet and open discussion forum where you can ask questions about specific agencies and read photographer reviews of these agencies. The association also offers statistics on various stock agencies (including a rating in terms of photographers' satisfaction), discounts on a variety of photo-related products, and other various services.

Most agencies are image exclusive, not photographer exclusive, so you can diversify and have several agencies representing different images. This means you can try out a few different agencies by

A Lesson Learned

Unfortunately, some agencies are not always honest or ethical about paying photographers the royalties due. Personal experience has shown me how important it is to be selective and cautious about the agency you choose. Some of my images were with an agency that was struggling financially. The owner decided to tell photographers that our images were not selling and kept the profits for himself. This is, of course, a form of copyright infringement and illegal. U.S. copyright laws provide for penalties of up to $150,000 per infringement! Coincidentally, several photographers found that their images was being used without compensation, and the agency claimed that there was an issue with the computer accounting program. Due to the number of complaints from photographers, PACA (Picture Archive Council of America), a trade organization that represents the legal aspects of stock archives, stepped in as a mediator. As a result, some of us were able to recover some of our lost residuals. While I am not trying to paint a bleak picture of stock agencies (and many are reputable), I am trying to open your eyes a bit and advise you to be cautious.

submitting different images to each one and determining what feels like a good fit. I currently have images at Corbis and Picade and can recommend both. Corbis is one of the top agencies in the world and is extremely particular about the images it accepts, but it is also looking for new work. Picade is run by photographers and may be an excellent place for some of your unique images.

Submission Policies

Each stock agency has its own guidelines to follow when submitting images for consideration. Some agencies will review your submissions and reply within a few weeks. Other agencies may not respond to you at all, due to the abundance of submissions they receive.

If you know someone whose photos are with an agency you are considering, try to get the contact information for an editor within the agency and contact him or her directly. A personal contact always moves you up to the front of the line.

Submit a variety of images (portraits, details, locations, etc.) and include variations of certain images you feel strongly about—vertical and horizontal, black and white, color, and various compositions. If agency editors like your work and feel that your style fits well with theirs, they will request that you sign a working agreement with them. Some agencies will allow you to upload images of your choice, while others will choose what they want.

All agencies have strict image-quality guidelines and will reject images that do not meet their quality standards. Agencies have a very specific editing and selection process and will not always choose your most dynamic, beautiful, or spectacular images. You might be surprised by the images they choose. They may seem ordinary to you, but will be the ones the agency can sell.

Keyword Your Images

As agencies struggle to maintain profits, many have begun requiring photographers to keyword their own images. Keywording means assigning specific words (adjectives, nouns, verbs, and so on) to the images. Choosing the right keywords increases visibility in a search field when a potential buyer is looking for an image to illustrate a product, service, feeling, concept, or metaphor. Irrelevant words will dilute the effectiveness of a search. It's best to choose no more than fifty of the most relevant words. Most agencies will give you guidelines, but here are some basic parameters to address when considering what words to attach to your images.

- Gender/person(s) (man, woman, couple, family, grandparent)
- Race or ethnicity
- Age
- Location (beach, oceanfront, sand, water, tides, Point Reyes, California, etc.)
- Occasion (wedding, picnic, etc.)
- Orientation (vertical, horizontal, landscape, portrait, oblong, panorama, etc.)
- Descriptive nouns, adjectives, verbs, and action verbs (happy, touching, kissing, embracing, romance, tender, love, sincerity, engagement, lifestyle, marriage, travel, etc.)
- Image type/tone/hue (color, black-and-white, sepia toned, abstract color, enhanced color saturated, muted, warm, vibrant, desaturated, antiqued, faded, etc.)

Programs such as Adobe Bridge and Lightroom also allow you to attach the photographer's name and contact information to each image (referred to as metadata). This enables someone who wishes to license your images to find you and, should your images ever be used without your permission, having your contact information embedded into the image provides a way to prove the perpetrator is guilty of copyright infringement. Some companies, such as keyword.com and metaworks.com, will keyword for you for a fee.

Licensing Images on Your Own

Photographers can also choose to license their images directly to buyers on their own. In fact, you can probably do so even if you are working with a stock agency, depending on your contract.

The advantage of licensing on your own, of course, is that you get 100 percent of the profits instead of sharing them with an agency. You may be able to market those offbeat images your stock agency might not want. For pricing, the best source is FotoQuote, the industry standard photography-pricing guide for stock and assignment photography.

Regardless of what you determine you should charge, you may come across a client who has a fixed budget and offers a lower price. You don't want to give away your precious work, but some money is better than no money, especially if your image is just sitting on your hard drive collecting dust. However much your clients are willing to pay, it's essential that they sign a stock license agreement that includes all usage details.

Once the agreement is signed, clients can make payment to you through your PayPal account or an online e-commerce merchant account. As soon as the payment has cleared, you will want to immediately send them the image(s) they paid for. This can be done either through e-mail or by uploading the images through a file transfer protocol (FTP) server, such as YouSendIt, which enables you to send large files via e-mail.

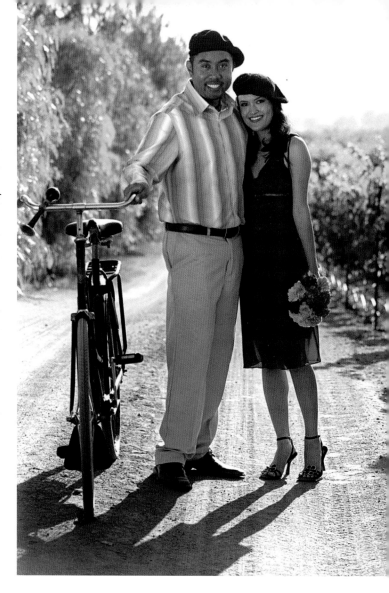

Above: One of my stock agencies chose this royalty-free engagement image, most likely due to the shortage of images of attractive, young, happy, affluent ethnic couples. The warm tone, bright colors, and bicycle made it especially appealing.

Nikon F100, 105mm Nikkor lens, Kodak 160NC film, 100 ASA, 1/250 sec. at f/2.8, natural ambient light and gold fill reflector

Opposite: I licensed this image directly to a company. My website has embedded metadata keywords such as "stock," "romance," "couples," "women," "sensuous," and "elegant" to make them likely to come up on search engines, and this must have been how the buyer found me.

Nikon F100, 85mm PC Nikkor lens, Kodak BW400CN film, 100 ASA, 1/60 sec. at f/2.8, natural ambient light

DÉCOR ART

Décor art, short for decorative art, encompasses posters, prints, calendars, coffee mugs, T-shirts, floor rugs, and just about anything else that features art and photography. Many companies represent décor art products exclusively, which in turn are sold in stores, on the Internet, and through other outlets.

As with stock photography, each company will have submission guidelines to follow. If their editors like your work and feel it would work well with their company's style, they will select the images they like and ask that you sign a working agreement with them. Before you sign a contract, research the company's track record and speak to some of the artists they represent.

Don't feel intimidated to ask question, especially regarding their payment process. In short, make sure the company is paying its artists and how you can know if and when your images are sold, and if so, for how much.

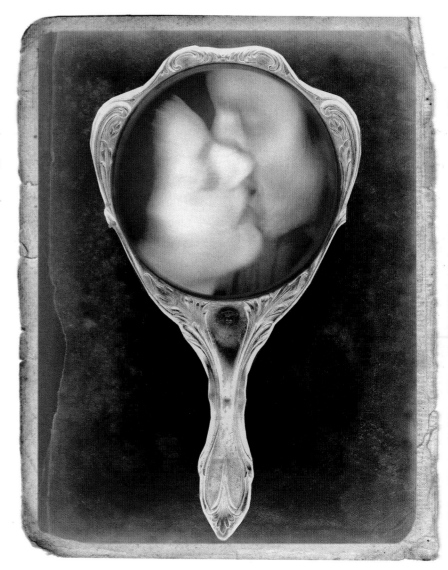

Right: This is an image montage from my fine-art collection, sold at an auction through a gallery in Los Angeles for $500.

Nikon F100, Kodak BW400NC film, 100 ASA

Opposite: I took the image on the right during a vintage-themed engagement session and sold the montage to a private collector for $350.

Nikon F100, Kodak BW400NC film, 100 ASA

FINE ART

Some of your engagement session images may well be considered fine art. Not only might your clients enjoy hanging prints of your images, but some images may be saleable as art work to a general market.

Of course, selling your work as fine art takes you into a whole new market. You may opt to work with a fine-art rep who will present your work to various markets, galleries, interior designers, and private collectors. A fine-art rep handles pricing, selling, negotiating, and scheduling, while the photographer focuses on the creative aspects.

Many fine-art reps charge a hefty percentage for this service (25 percent to 50 percent of your profits); even so, paying for the convenience of a service like this may prove to be more profitable in the long run. As a photographer, you want to spend your time working with clients and producing beautiful images, not selling art.

Your prints should be archival, fine-art-museum quality. I use an Epson Pro 4000 printer with pigment dye inks that produces color prints estimated to last 108 years and black-and-white prints approximately 200 years. You can also have your prints made by a custom printer. I use Marco Fine Arts in El Segundo, California. They are by far the best and handle every kind of large-format digital printing from Giclee prints and lithographs to canvas and framing.

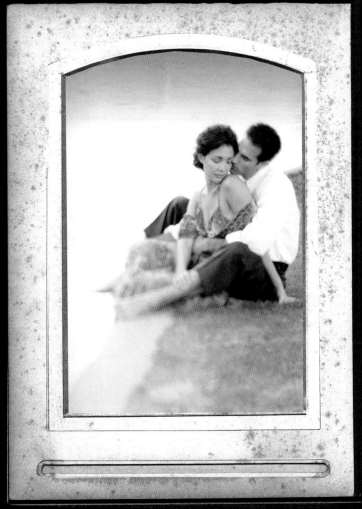

AN ENGAGEMENT SESSION . . .

at the Beach

Beaches are among the most romantic places on earth and ideal backdrops for great engagement images. You don't need to live near an ocean to take advantage of a beach setting—a lake, small pond, river, or even creek can provide the same magic. The secret ingredient is water, a powerful, sensuous, and romantic force. The sound and appearance of water usually helps us relax, inspires us to dream, and can make us feel playful. Explore these effects and see what you can achieve.

Some couples choose a particular beach for their own sentimental reasons—maybe it's the place they had their first kiss, fell in love, or became engaged. Other couples simply love the idea of shooting on a beach to escape the stresses of planning a wedding for a romantic day in a paradise-like setting.

Opposite: This old wooden sign found along a pathway leading to the beach was a perfect location detail to support the beach theme. If you can't find an authentic sign, you can always make one with a piece of driftwood, some paint, and a steady hand.

Nikon F100, 28–105mm Nikkor lens, Kodak BW400CN film, 100 ASA, 1/60 sec. at *f*/5.6, natural ambient light

Above: A sensuous still-life image of the ocean tides such as this one can set the tone for beach themes and make a great framed fine-art piece.

Nikon F100, 85mm PC Nikkor lens, Kodak 400NC film, 200 ASA, 1/125 sec. at *f*/2.8, natural ambient light

PREPARATION AND OBSTACLES: Sand, dust, wind, and salt air are all challenges. Be prepared to cover your gear with a dry, sand-free cloth or blanket when changing lenses, film, or digital cards. You want to avoid sand and salty air from entering your equipment, where they can erode the electrical contacts, grind components, and scratch lenses. I always bring two blankets: one to protect my gear and the other to wrap around the couple for a few cuddling shots. Weather is another factor to keep in mind, as temperatures are usually lower at beaches than they are inland. I always remind my clients to bring some warm clothing they can layer on, if the temperature should suddenly drop. You and your clients should bring some warm, dry clothing to slip into for the drive home. If I know that I will be shooting in or near the water, I might even wear my wetsuit. This allows me more comfort and mobility and helps me to capture more dynamic images.

WARDROBE: When shooting at the beach, I always ask my couples to bring at least a couple of outfits, both casual and elegant attire for variety. For causal attire, I love to see them wearing all white for a Zen look. For elegant attire, I think of a guy wearing a suit or a girl in a black cocktail dress standing against a blue ocean with a soft pink or blue sky—there's nothing sexier.

HAIR AND MAKEUP: A bit of hairspray, for both men and women, can keep hair from going out of control on a windy beach (unless you're going for a messy, wild look). Makeup should be minimal, low-key, and natural to match the natural setting. I usually opt for paler shades of pink and rose lipstick or blush and a very light coat of foundation.

PROPS: The natural backdrop of a beach should provide most of the ambiance you need—think of palms, birds, seashells in the sand, and dolphins playing in the surf. You might want to add a bottle of wine, a wicker picnic basket, and a checkered blanket. Since the beach is also synonymous with surfing (at least here in Southern California), how about a surfboard, wetsuits, and maybe even a pair of flip-flops lying next to two towels? A pair of deck chairs, a book, and a glass of wine might also work. If you're shooting near a lake or harbor, you might want to set the mood with a colorful rowboat and some fishing poles. These kinds of props are great because they become interactive parts of the scene and can take your images to the next level. This being said, make sure to have everything arranged ahead of time so your shoot runs smoothly.

LIGHTING CONSIDERATIONS: Shooting in the open space of a beach can present lighting challenges, unless you are working in soft light (sunset, sunrise, or on an overcast day). This should ensure that you will capture the most flattering results (without the need for cumbersome diffusers to control unflattering contrasting shadows and highlights). Whether you're shooting during the magic of late-afternoon light or on a misty, overcast day, you'll discover a mood and feeling that can produce beautiful results.

Opposite: Get creative! Wet sand provided a mirror with which to capture this shadow reflection.

Nikon F100, 28–105mm Nikkor lens, Kodak BW400CN film, 100 ASA, 1/125 sec. at f/4.5, natural ambient light

Below: Doves are a symbol of love, and in some cultures setting one free represents letting go of part of one's life to prepare for the next. I used a fake white bird purchased at a prop shop for this image.

Nikon F100, 28–105mm Nikkor lens, Kodak 400NC film, 200 ASA, 1/60 sec. at f/4.5, natural ambient light

Opposite: If you enjoy shooting nature or landscapes, all you have to do is toss in a romantic couple to achieve a gorgeous romantic shot! Here, dual water sources provide a great reflection. This was taken moments before the sun escaped over the horizon. Don't pack up your gear thinking there's no light left at this time of the evening, when the so-called magic hour can produce some of the most beautiful light in the world.

Nikon F100, 85mm PC Nikkor lens, Kodak 400NC film, 200 ASA, 1/60 sec. at f/2.8, natural ambient light

Left: Focusing on the footprints in the foreground while this couple escaped into the sunset gives this image a creative twist. I'm always keeping in mind possible stock images, and, with all the metaphors the footprints suggest, this shot became one of them!

Nikon F100, 105mm Nikkor lens, Kodak 400NC film, 200 ASA, 1/125 sec. at f/2.8

Below: Beaches usually induce a relaxed mood in your subjects, making it easy to capture upbeat shots like this.

Nikon D700, 105mm Nikkor lens, ISO 320, 1/250th sec. at f/2.8, Nikon SB900 flash (w/Apollo flash diffuser box) and natural ambient light

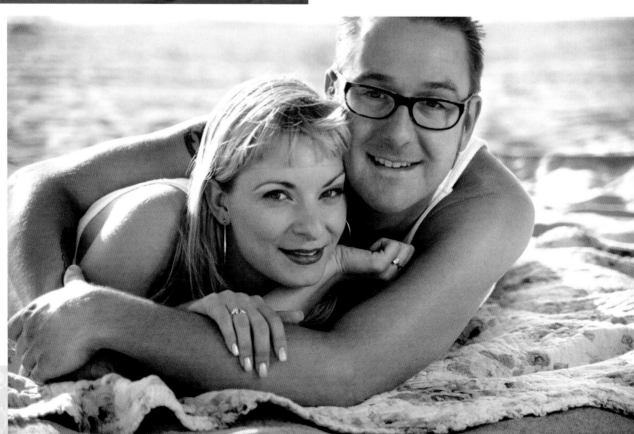

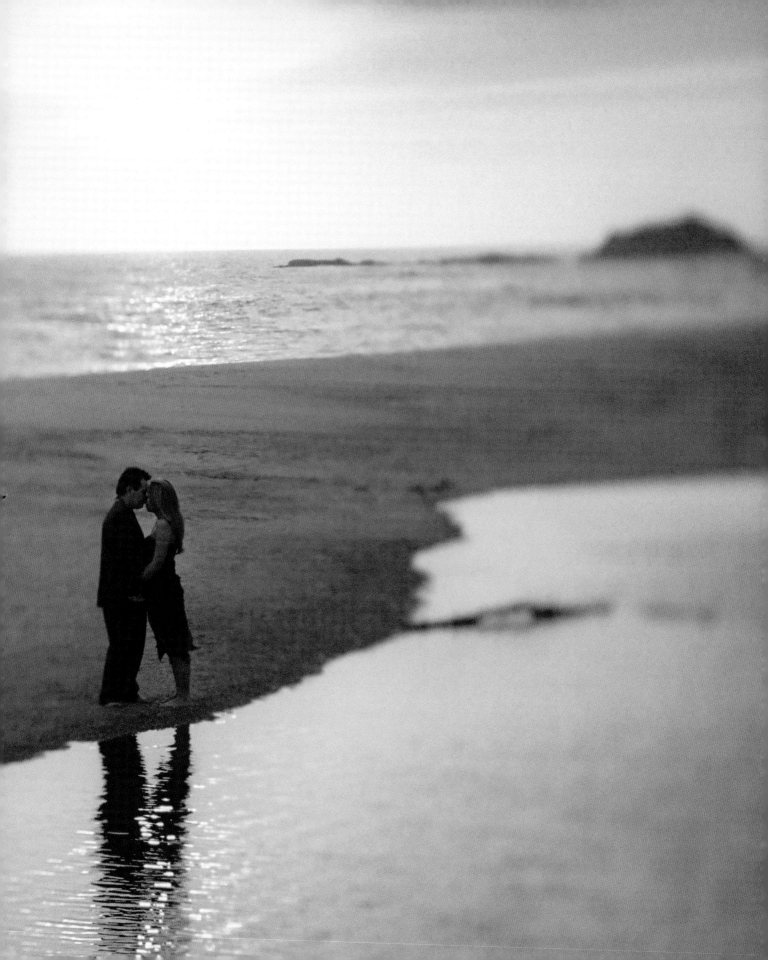

RESOURCES

Services, gear, and other valuable resources for engagement photographers are readily available.

Magazines

Aftercapture, the magazine for all your post-production photography techniques, www.aftercapture.com

PDN, dedicated to all subjects of the photography world, www.pdnonline.com

Rangefinder, dedicated to portrait and wedding photography, www.rangefindermag.com

Photography Conventions, Trade Shows, and Expos

PDN Photoplus International Expo, October, New York, one of the largest photography conventions on the East Coast, www.photoplusexpo.com

WPPI (Wedding Portrait Photographers International) Convention and Trade Show, with *Rangefinder* magazine, February, Las Vegas, one of the largest photography conventions in the West, www.wppionline.com

Photography Support Groups and Trade Organizations

American Society of Media Photographers (ASMP), promotes photographers' rights, educates photographers in better business practices, produces business publications for photographers, and helps buyers find professional photographers, www.asmp.org

Picture Archive Council of America (PACA), dedicated to fostering and protecting the interests of the picture archive community through advocacy, education, and communication, www.pacaoffice.org

Professional Photographers of America (PPA), the largest nonprofit association for professional photographers in the world, www.ppa.com

Stock Artists Alliance (SAA), the only trade association focused exclusively on the business of stock photography, www.stockartistsalliance.org

Photography Equipment and Supplies

Epson, affordable printers for pro photographers, www.epson.com

Gitzo, strong, light, durable tripods, www.gitzo.com

Kodak, excellent photographic paper and film, www.kodak.com

Lexar, reliable memory cards, car readers, and hard drives for digital cameras, www.lexar.com

Lowel, tungsten/halogen, LED, and fluorescent lighting systems, www.lowel.com

Nikon, cameras, lens, filters, flashes, and accessories, www.nikon.com

Tamrac, sturdy camera bags, straps, and accessories, www.tamrac.com

Think Tank, roller bags and camera equipment pouches, www.thinktankphoto.com

Photography Workshops

Dream Team Photo Workshops, weekend intensive workshops dedicated to teaching how to earn the most from your photography, directed by Elizabeth Etienne, www.dreamteamphotoworkshops.com

Photography Consulting

Elizabeth Etienne Photography, one-on-one consultations for every aspect of a photography career, www.eephoto.com and www.elizabethetienne.com

This is the cover of my "Timeless Lifestyles" portfolio. I selected a pale natural leather cover and had a custom name-stamp plate made (about $80). To "age" the leather exterior, I scratched the surface with a Brillo pad and then gently blotted Fiebings Antique Finish Leather Dye (commonly used to dye saddles and other leather equestrian tack) to create a strong patina look. The book definitely grabs attention.

Industry Blogs

Elizabeth Etienne Photography, tech tips, business advice, portfolio reviews, shoot session samples, and more, www.elizabethetiennephotography.blogspot.com

Marketing Essentials International, marketing consulting for the photography industry, www.skipsphotonetwork.com

Computer Equipment and Programs

Adobe computer programs (Photoshop, Bridge, Lightroom, In Design, and Illustrator), www.adobe.com

Apple Mac computers, www.apple.com

Fotoquote, industry standard pricing guide for stock and assignment photography, www.cradocfotosoftware.com

Keyword.com, keyword marketing promotion service, www.keyword.com

PictureCode Noise Ninja, a Photoshop plug-in filter that softens skin tones, www.picturecode.com

YouSendIt.com, online service that allows users to send and receive large files, www.yousendit.com

Album Bookmaking Companies

Samy's Camera, Santa Barbara, CA, beautiful, affordable, hardbound album books, www.samys.com

Pikto Albums, one of the few manufacturers of affordable lay-flat books, www.pikto.com/about

Stock Photography

Corbis, premium-quality stock photography and illustration, www.corbis.com

Picade, the only all-photographer owned and operated, exclusively rights-managed stock agency in the world, www.picade.com

Website Templates

Photobiz.com, ready-made, user-friendly, affordable flash and html website templates, with an online proofing service, e-commerce website, hosting and unlimited tech support a monthly fee, www.photobiz.com

Art Supplies for Gift Boxes and Packaging

Aaron Brothers Art Supplies, www.aaronbrothers.com

Fiebings antique finish leather dye, www.fiebing.com

Rotatrim, top-quality British-made precision cutting equipment for professional and amateur arts and crafts, www.rotatrim.co.uk

Photo Craft Suppliers

Iphoto calendars, reasonably priced, high-quality printing, www.apple.com/ilife/iphoto/print-products.html

Kodak Gallery, unique photo-related products, www.kodakgallery.com

Moo.com, unique business and postcard cards that allow you to print a different image on every card in a pack, choose miniature cards, and order small quantities of cards at a low price, us.moo.com

Printed Promotional Materials

Modernpostcard.com, online printer for promotional mailers, business cards, brochures, posters and other printed materials, www.modernpostcard.com

e-booksartist.com, custom interactive e-books using photos, text, video, links to websites, and music, www.e-booksartist.com

Fine Art Gallery Prints

Marco Fine Arts, high-quality printing services, www.mfatalon.com

INDEX